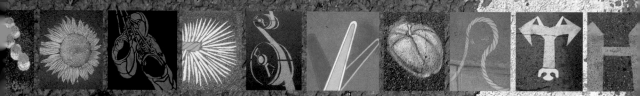

text by
ROADSWORTH and BETHANY GIBSON
with a foreword by Scott Burnham

GOOSE LANE

To my sun and my light, Keyan and Luscia
— Roadsworth

To my brother and my sister, for the inspiration
— Bethany Gibson

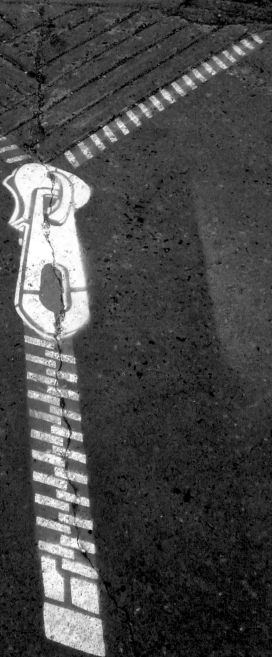

Scott Burnham

THE MISSING MANUAL

The street is a symbol of our commonality. Regardless of individual status, income or background, the streets of our cities are the platforms that enable our lives to take place, that create our histories. When we are children, the streets and sidewalks are both entertainment areas and coming-of-age markers. For the younger set, a piece of chalk can turn the sidewalk in front of a building into a game board. For the slightly older, there comes a single day of maturity and empowerment when you are given permission to cross the street by yourself, and another world of independence opens up as you discover on your own terms what is on the other side.

The shared connection to the street is woven within our language. The vast urban expanse is transformed into a collection of personal areas when we talk about *my* street or *your* street. If a city is jubilant about a sporting victory or other celebration, the residents are said to be "dancing in the streets." If a certain neighbourhood has a darker side, you are often warned not to be "out on the streets" late at night.

It is in our human nature to see the streets as personal, narrative threads weaving through our lives. Yet in one of the final rites of passage into adulthood, when we

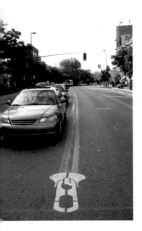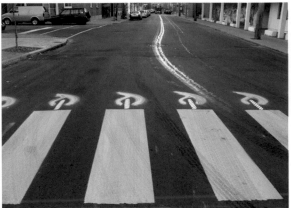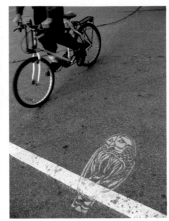

learn to drive, we are told that we've been wrong about the openness of the streets. There is a code of conduct. There are laws. There is an iconography of symbols and markings that will tell you these rules. It is an unfamiliar visual language — sets of patterns, lines, shapes and symbols that are to be translated into human behaviours. We are told to study them closely: we will be tested on these markers, and if we don't follow their dictates, we will be fined, or worse. We're playing by someone else's rules now.

Then one day you are on the street as driver, pedestrian or bicyclist. You've studied the markings, you know their iconography and instructions — the dotted white lines, the solid yellows, the zigzags leading to a stop. You now speak this language, and the symbols are no longer studied like language flash cards with the translations on the back; they are understood as given. You've accepted the enforced order of the street and you follow along. But as obedient a student of the language as you've been, you can't remember what you are supposed to do when a zipper marks the merging of lanes. If thick, solid white lines are pedestrian crossing areas, what takes place at the line of large candles? How about at the giant shoe print? Dotted lines mean you can change lanes, solid lines mean you can't. So what does an EKG heartbeat line tell you to do?

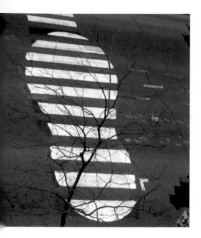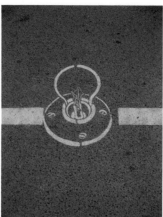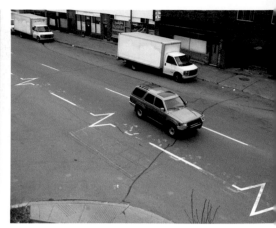

Roadsworth's work plays with more than the visual language of the city; it plays with our relationship with the city. It returns us to the moment in our youth when the streets and sidewalks could hold moments of our play and humanity, before we learned that they were the domain of structure and order. His work asks questions in a streetscape of absolute instructions, and invites double-takes and smiles in areas where you're supposed to be quiet and fall in line.

To begin a discussion on Roadsworth's work, the mode of delivery and our perception of it must almost precede the work itself. Roadsworth's work unfolds itself into our consciousness the same way our understanding of the streets does when we are in a foreign city. The lines and symbols on the pavement are clearly telling you *something*, but it is a language varied from the one you are used to in your home city. You pause from your instinctive routine to learn and adapt to these new instructions. There is an experiential harmony in the process of understanding Roadsworth's work — a harmony between learning his language and reconsidering our own understanding and behaviour within the city.

The word *subversion* is often used in conjunction with Roadsworth's work, more out of a lack of effort to think more deeply about his work than from a desire to use one of the handful of terms instinctively used to describe street art. *Realignment*

may be a more fitting word to consider with respect to his work. In the ideally democratic terrain of the city, there is an imagined equality in the streets, but cars and machinery hold considerably more influence merely by the vote of their size and presence. One quickly learns that elements such as pedestrian markings aren't there exclusively to designate the right of passage for pedestrians, but also to provide protection from the cars. As citizens on the streets, we seek out these lines as some sort of safety zone, an area that grants us permission to have the right of way for a brief moment against the stream of vehicles. When you move around different cities, you realize that each city's relationship with these markers is also an indicator of its personality. The stitched lines of a crosswalk may be identical in every city, but they are treated with varying degrees of respect by drivers depending upon which city you're in.

Roadsworth's crosswalk made into a huge shoe print is a realignment of the presence of the pedestrian in the city — a piece of visual advocacy for the rights of the individual across the pathway of steel machines. Images of barbed wire lining crossing areas, velvet ropes cordoning off pedestrian paths, heartbeats registering our increased pulse rate when crossing the street — the elevation of our human presence in the city, through his human touch, creates brief moments where the imbalance of presence amongst the elements sharing the street is redressed.

Political agenda is another phrase that floats around some descriptions of his work. This energy is there, but as with subversion, it has only a minor role in this play. There are certainly agenda items at work — bicyclist advocacy, anti-car, pro-pedestrian — but what rises above all else is a rare element of poetic discovery of the potential stored within the normally anonymous pavements. Roadsworth's nod to Andy Goldsworthy in his name holds more than simply nomenclature. In the same way that Goldsworthy draws a hidden energy from the rocks, trees and

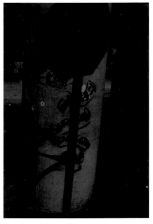

soil of the countryside, Roadsworth awakens and reveals a dormant energy contained within the street and the urban ephemera. For the viewer, the magic of Goldsworthy is in looking at his assemblage of rocks and wood and realizing that this possibility existed in the raw material all along but needed an artisan's eye and craft to reveal it. Roadsworth's dormant material waiting to be sprung to life is the urban surface and its objects and markings. One of his earliest works, a manhole cover painted to depict a soda can top ready to be popped open, can now be seen as a calling card for what was to come next — the opening of the street by his hands.

The craft and intelligence within his visual call and response to the topography of the streets brought due attention (some forms more gladly received than others), but for those following his creative development, his increased profile and growing body of work also posed a question: could the energy of the early road markings be extended beyond the literal visual play?

His shadow-play line of work was a resounding response to this question. It seems an obvious extension of his ethos to play with another visual aspect of the street, but the beauty comes in the realization that it is in fact a complete reversal of our previous understanding of his work. If you come across the shadow works during the day, when the majority of a city's population moves about, you may see the markings but they will be impossible to understand on their own. They pose a question back to people in the same way that the city's street markings do when

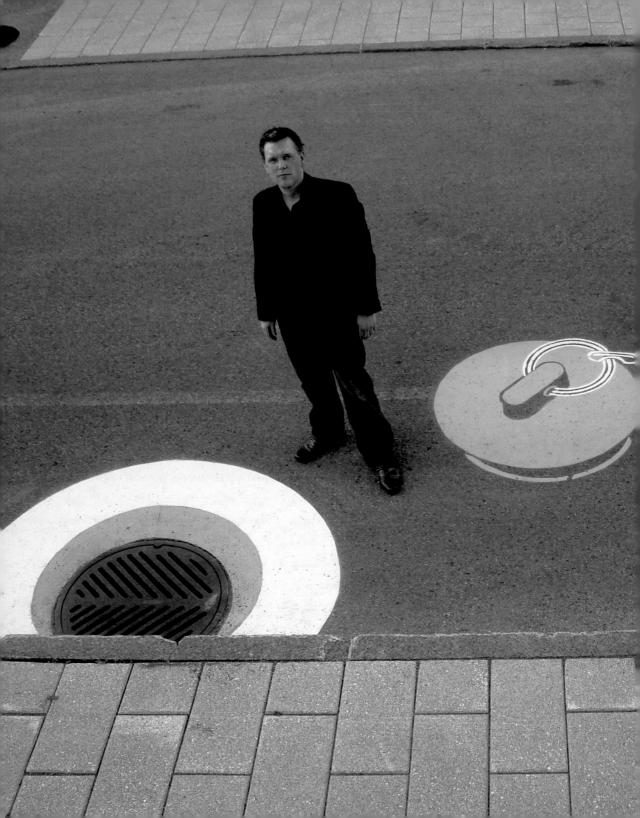

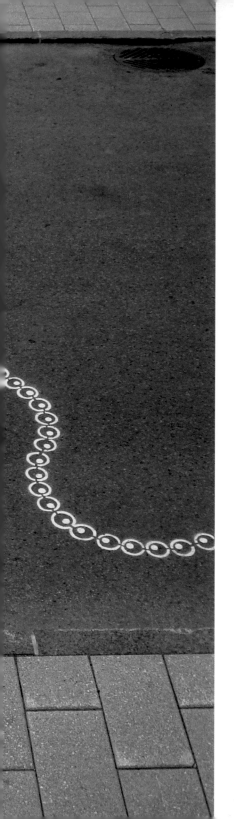

we are first learning them: these markings and images mean *something*, but you have to learn them, work them out on your own. In the light of day there isn't enough information to learn what they are communicating. It is only when the city does its part by turning on the evening's street lamps that the works come to life and can be understood. This situation adds an intriguing depth to his, and our, relationship with the city. The work now doesn't rework the city but relies on the city to breathe life into it. It is not so much site specific, for the paint is at the same place during the day, as site *and* time specific. It personifies the vulnerability of subtlety in the city. If the illuminating street lamp burns out, so does the work that relies on this light. If someone stands in the path of the light, the work is rendered helpless until they move.

Yet something more vital also takes place during the shadow works. It creates relationships between everything sharing the city that night — objects, people, light and space. Standing in the silence of the night, viewing a bench's shadow that has become a bible, or a power line's shadow on which an owl perches, the viewer finds that not only is he or she part of a special moment in the city, but so is the lamp, the bench, the power cable and the street. The individual and the pieces of the city come together to create this one work — a moment of great subtlety born from a landscape devoid of subtlety.

This sense of visual play is found across his range of playful works that appear in a looser context with the city. Moving on from

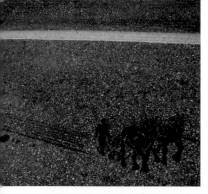

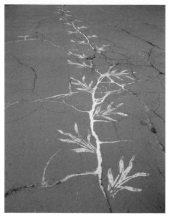

reworking the existing instructions of the city, Roadsworth creates new instructions — ones that encourage a playful relationship with an area that has been designed to prevent play. By creating new visuals in previously bare paved areas, Roadsworth presents pedestrians with their own set of markings and guidelines, exclusive and detached from the dominance of vehicular instructions. At times joyful, surreal or playfully menacing, these visuals in the city tell those travelling by foot or bike that it's now their turn to navigate the streets by a different set of rules.

The fluidity of Roadsworth's relationship with the city, and the relationships he creates for others, is most powerfully represented in one of his less populated areas of work — his augmentation of the scars of the street. The tire skid marks, gouges from metal scraping across pavement, or cracks splitting the pavement are the stories of when control and order in the city was lost — when the order and control that the street's systems are supposed to provide broke down. By taking these moments of broken order into his care and crafting the tire skid into furrows made by a horse team and plough, or transforming cracks in the pavement into branches of a tree, he offers them back to the city in a repaired state. Whether intentionally or not, these works appear as an appreciative gesture towards the allowance the city has shown for letting him play in its terrain. In these moments he himself has become part of the organic process at work in the city.

The techniques and relationships created between object, imagery and function combine in the commissions that have defined Roadsworth's work in recent years.

To those quickly passing in a car or on a bike, they work with the readily understood tokens of beauty or fun. For those who look more closely — perhaps in an effort to slow down the pace of the city — there is a depth and a narrative made possible by his having formed a relationship with the street and having workshopped his ideas at the sharper edge of legality. The commissions allow Roadsworth to expand his vocabulary in areas that provide time and space for both himself and the spectator to work towards creating a new, shared visual vocabulary.

Given the luxury of viewing a decade-long survey of his work, we can see the layers; the narrative and cumulative process and progress reveal themselves clearly. We have come to understand his work in the same way we learned to understand the order and structure of the streets over the years. We assimilated that language through experience and acclimated to its instruction. In the same way, we have gained a learned understanding of his reworked visual language of the street. There has always been a shared relationship between people in the city; Roadsworth has expanded this relationship to encompass the people, objects, markings, shapes and shadows, and bring them into our sense of a personal relationship with the city.

When first discovering his early work, I once joked that looking at images of his reworked street markings made me wonder if there was a supplement to my driver's instruction manual that I had missed when I was learning the language of the street. As his work has expanded over the years to encompass so much more of the urban ephemera and our relationship with it, that missing manual would now include a vastly expanded range of images, objects and relationships that we need to learn in the city. This book could be that manual.

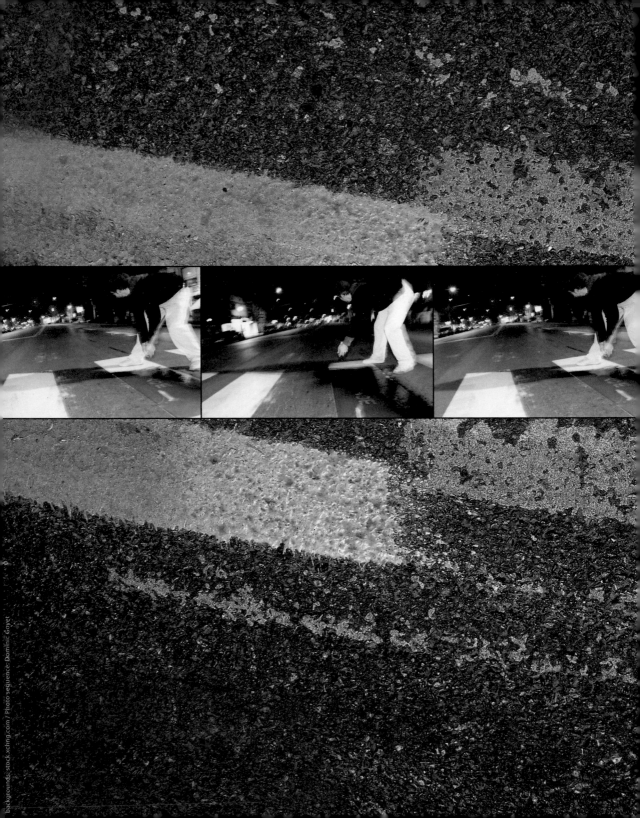

my arm, suddenly heavy and awkward.

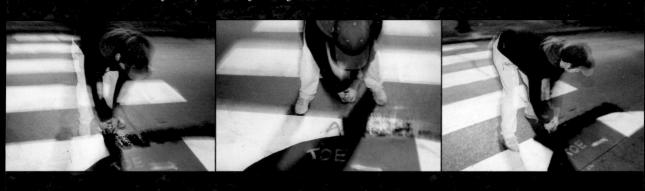

I have turned this into a kind of meditation. My heart used to race, but I learned to slow it with my head, to talk myself through staying calm and focused, and now the alertness overwhelms everything. This is never going to be comfortable — and shouldn't be.

This is the place. I walked through this intersection last night. The two streets are both one-way—not too much traffic. I leave my bike around the side of a depanneur on the corner. It's illuminated from the inside, a Boréale ad in the window. I leave the portfolio some distance from my bike, against a tree, make it an incidental object. You notice the strangest things lying around a city in the wee hours: running shoes tied together dangle from a hydro line over my head. My backpack stays with the board, on the other side of the spindly sidewalk tree, a cartoon-ridiculous hiding spot. Pull a can out of the pack and up my right sleeve in one motion.

I'm just hanging out, an innocent bystander. I pat my jacket pocket and cigarettes I hope not to have to smoke. Open the portfolio, take the board out. Walk to the next tree, closer to the corner, lean the board against it. Wait. Watch. Listen. Sirens some distance away. Freeze. The sound recedes. Pick up the board and walk to the spot with intent, lay down the stencil carefully, no fussy adjustments, and keep walking. At the opposite corner stop and wait.

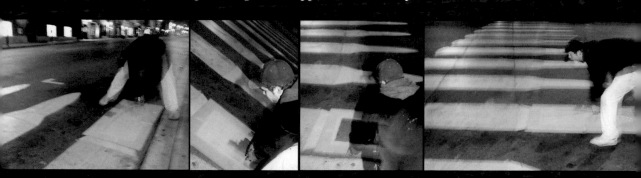

A car is coming, slowly, from the wrong direction along a one-way street, two blocks away. This is a good time to light up. The car turns at a corner before this intersection. It's not a cop car. Abandon cigarettes to pocket. Shake can crooked against my wrist while I walk. Push the stencil with my toe into position, keep walking. Check how it looks from here, check streets in all four directions: empty. Shake, walk, bend low and spray.

The *kssst* sparks the same involuntary response every time: I imagine all eyes and ears on me. No mask tonight, so I hold my breath. At least there's airflow; as fresh as it gets, with an undertone of diesel. Walk. Check the chain on my bike, which has never given me problems. Back again, spray, spend more time with it, make the colour deeper, imagine drenching the pavement, soaking it through. Be decisive. Walk and wait.

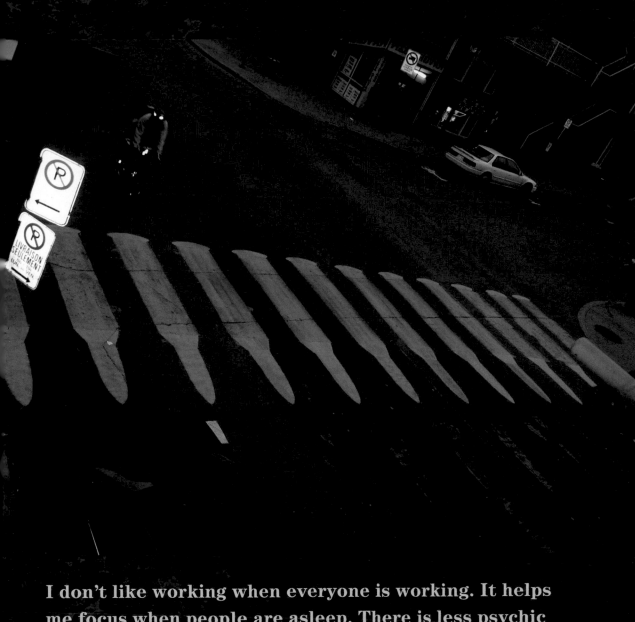

I don't like working when everyone is working. It helps me focus when people are asleep. There is less psychic energy around. You can hear yourself think. You're not in the same race as everyone else.

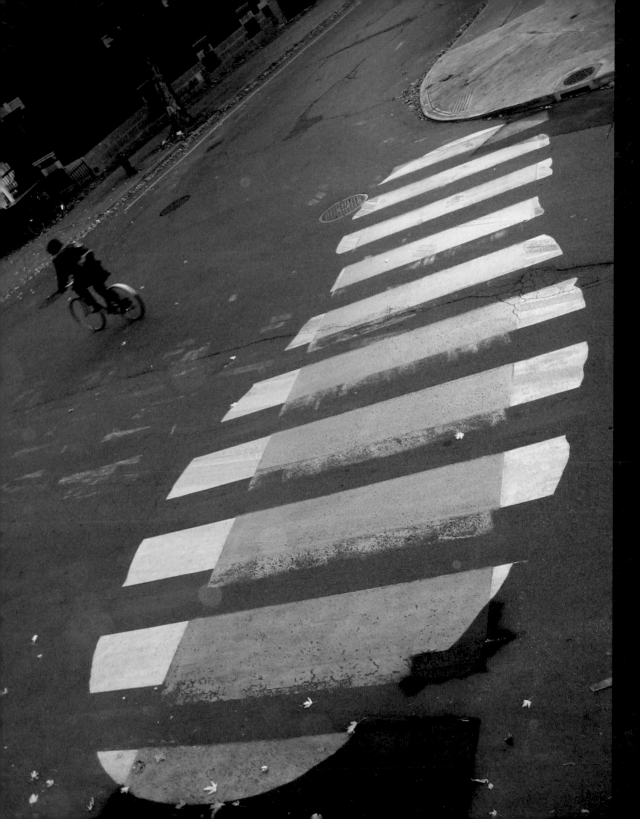

It's so quiet. I love the city now. This intimacy—just the city and me—
I can't access during the day.

To another corner, in the shadow of a building. Crouch and untie then
retie my shoe. One more pass, maybe two. I have to know when to stop,
and I don't always.

Quick pass back, lift the board, notice only now how yellow my fingers and
shoes are. Back at my bike, stop for a beat, to look around, ready to reach
for the smokes. Straddle my bike, a couple of awkward steps over to drop
can in pack, lift pack onto my back, portfolio under my arm. I push off,
move, keep moving.

Should I do one more, or call it a night?

A barely noticeable tick of fear is starting up. I'll go for one more, and
look forward to the ride home when I will feel that rush, a kind of triumph,
if only over my own fear and doubt. I'll wake up later today and think:
I went too far this time.

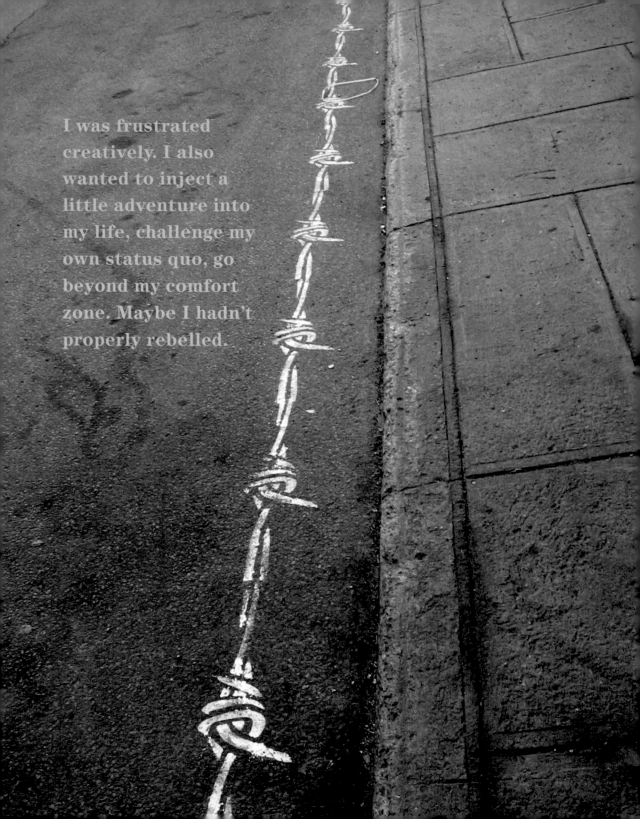

I was frustrated creatively. I also wanted to inject a little adventure into my life, challenge my own status quo, go beyond my comfort zone. Maybe I hadn't properly rebelled.

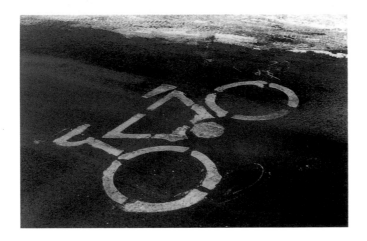

BIKES

Roadsworth's stencilled images started sprouting on the streets of Montreal near the end of October 2001.

First a bicycle, looking suspiciously like the symbol used by the city to designate a bike path. It was a political and environmental statement. It was also — at the same time and inseparable from a form of activism — a witty nod to the passerby: the bikes, which appeared in random locations around the city, were laid down in the middle of the road. A call for bikes to take over. The bike stencil pushed out into a three-dimensional design, and soon other images were proliferating on the pavement. While many thought the first stencils might have been the work of the city, by the time the more complex, humorous, audacious designs started appearing, it became clear this was something else entirely.

Roadsworth was living above a grocery store on avenue du Parc, in the Mile End neighbourhood of Montreal, composing, playing and recording electronic music, and working as a security guard at the Musée d'art contemporain de Montréal.

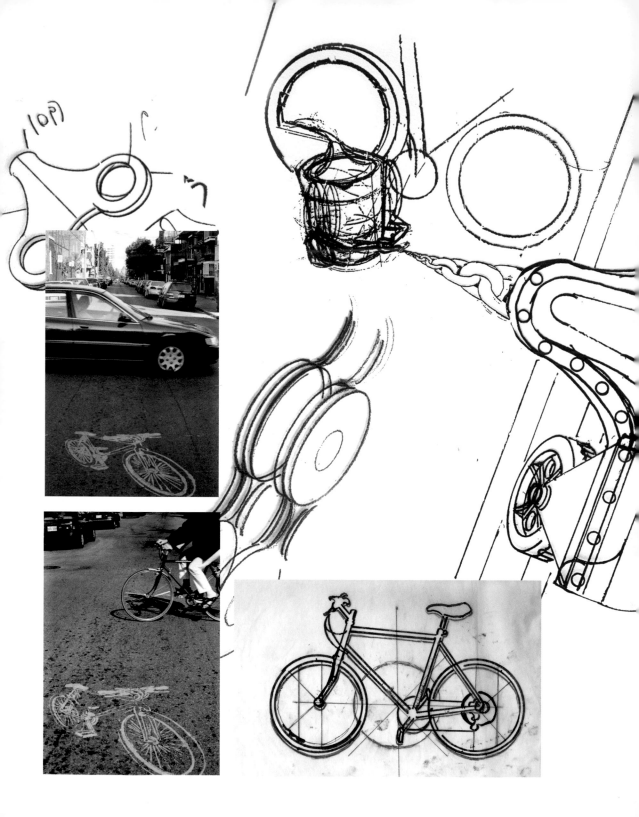

Inspired by the nature-work of artist Andy Goldsworthy — interested primarily in the sense of play that characterizes his work and the minimal interference involved in its creation — Roadsworth started playing with rocks on the roof of his building at night, making and manipulating shadows.

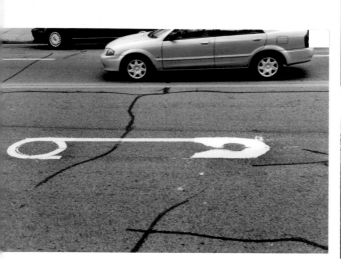

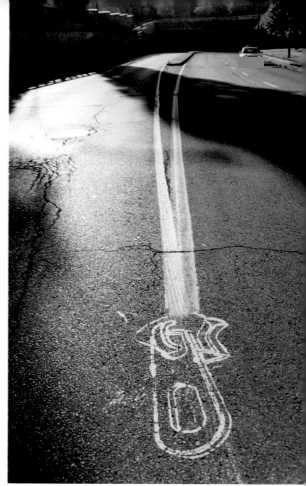

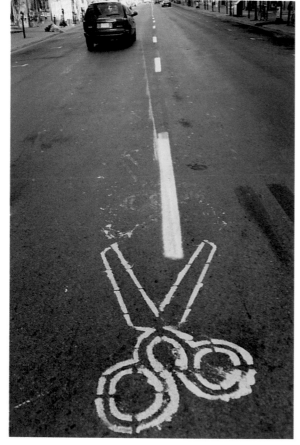

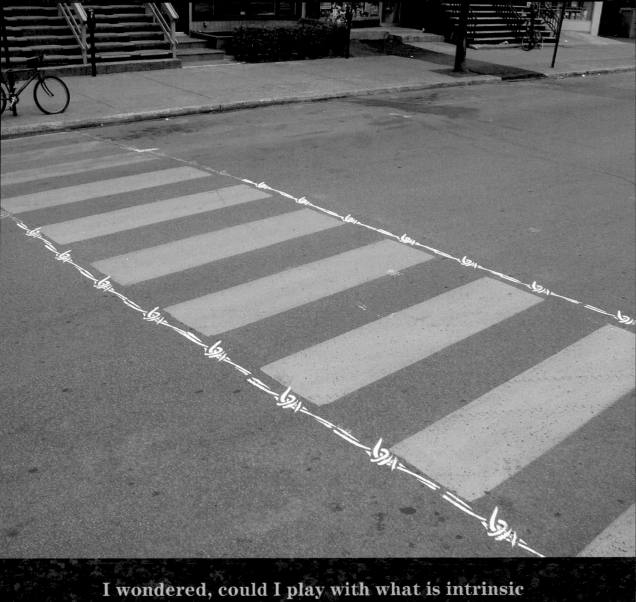

I wondered, could I play with what is intrinsic
to the urban setting? I wondered especially
about the lines on the road.

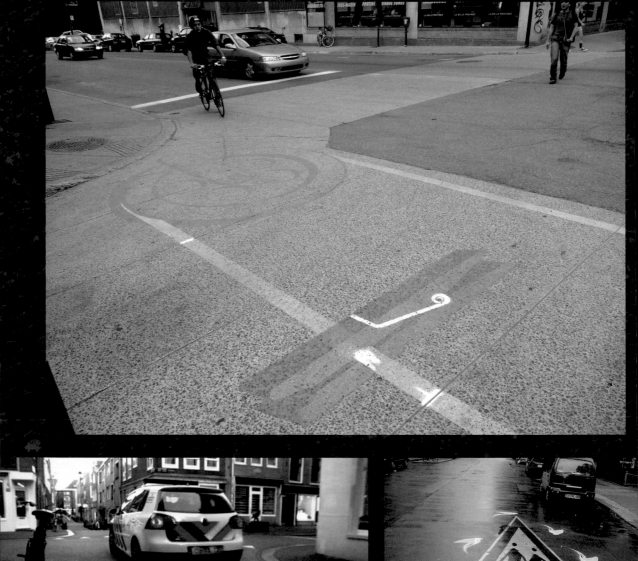
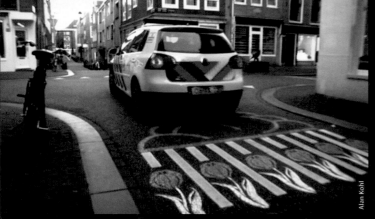
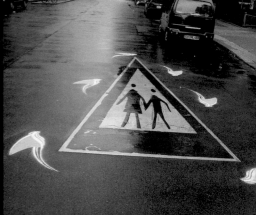

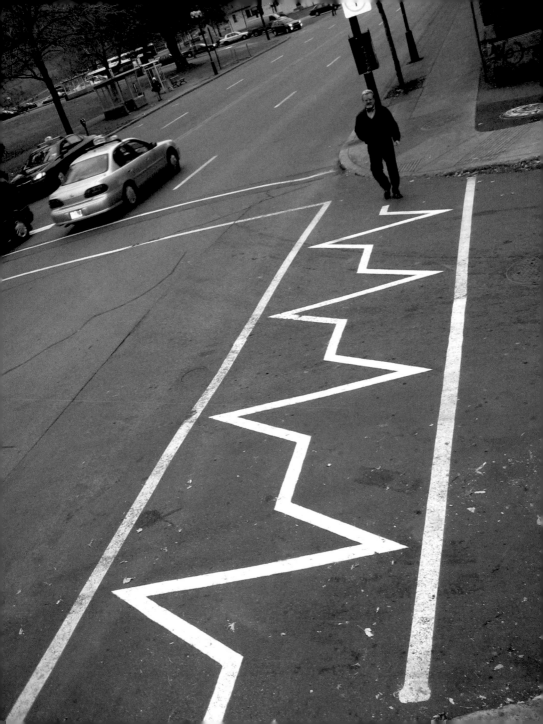

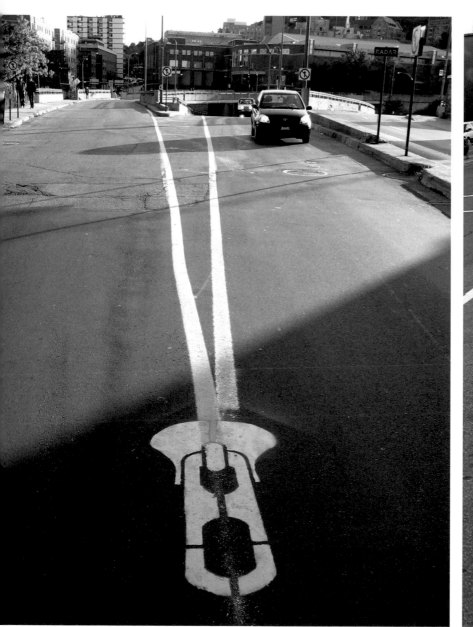

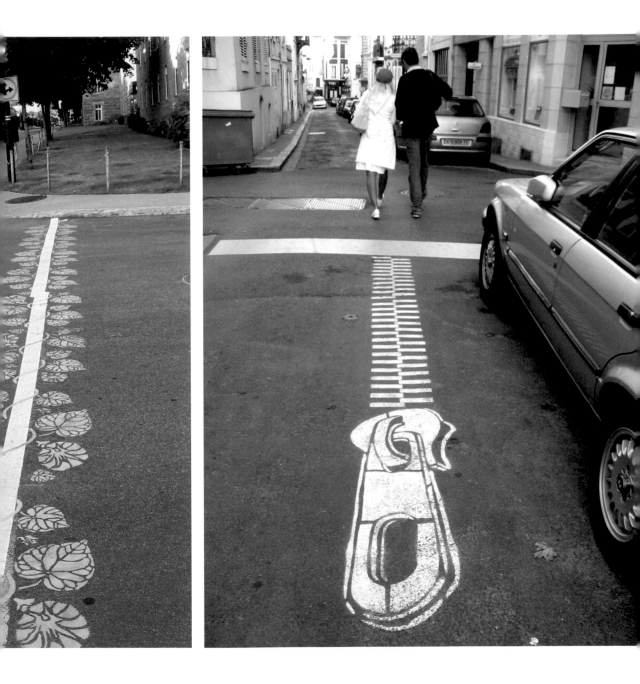

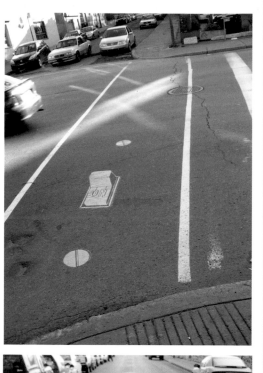

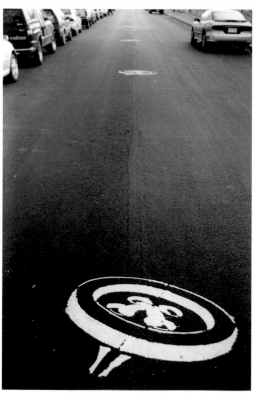

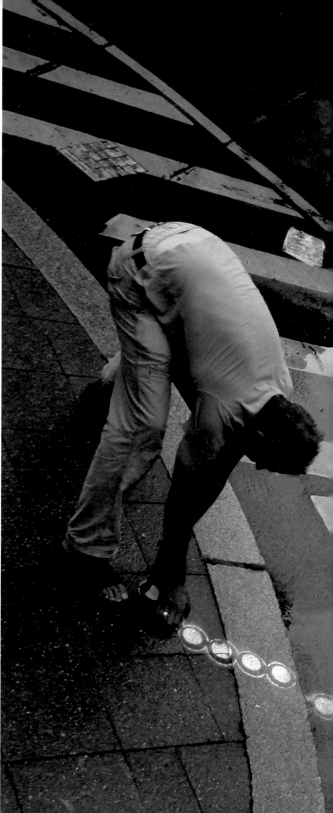

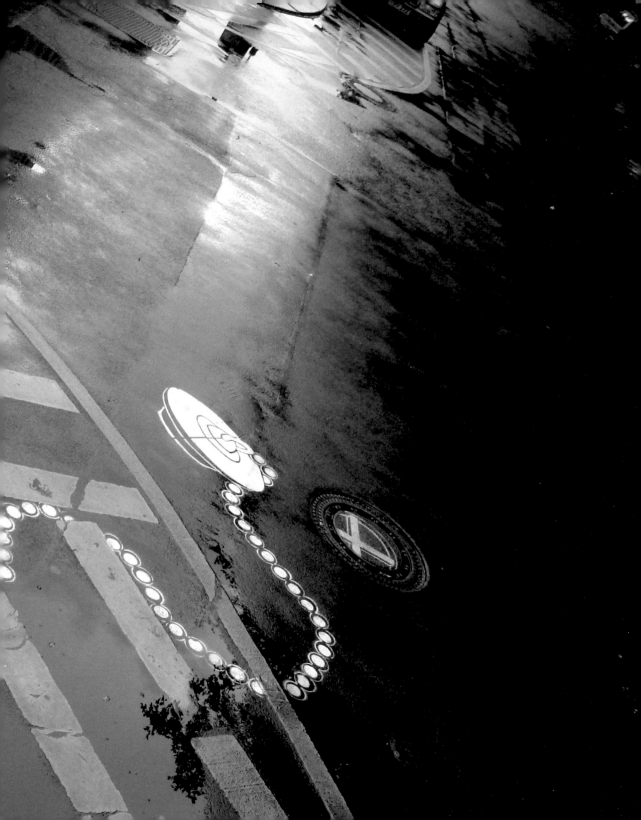

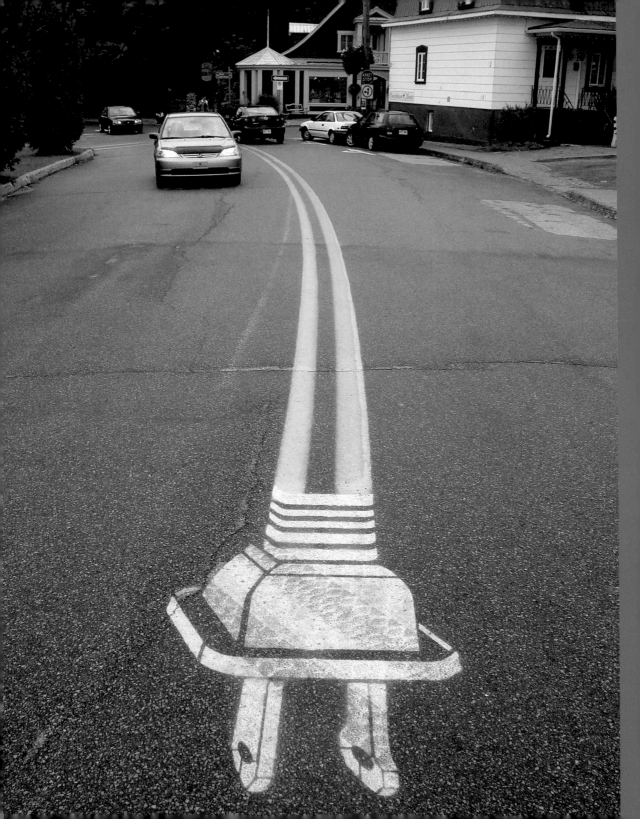

CARS

As a cyclist and pedestrian in a big city, Roadsworth experiences viscerally and daily the density, noise and pollution of urban living. And in 2001, it was getting to him.

When I started, I didn't have a clearly defined manifesto. I had a sense that our modern lifestyle was generally unsound and unsustainable, and car culture epitomized that condition to me.

The car is a place of comfort, insulated from the outside world. A car feels "safe" and doesn't demand exertion. Driving is a predictable and comfortable experience for the most part, and—as with most comfort zones—it's not necessarily good for us. Car culture is the status quo. It does not challenge or demand change, and it is defined by its own inertia, on a societal scale.

The sight of never-ending lines of single-passenger cars, in a city with an abundance of alternate forms of transportation, strikes me as absurd. It suggests a hyper-individualistic mindset that denies the

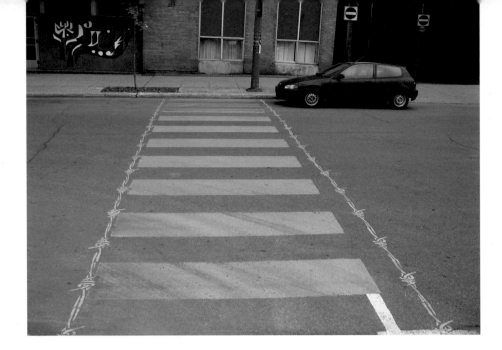

natural environment and the presence of — and necessary connection with — a larger community, a larger world.

Our dependence on cars speaks to me of collective denial, particularly in regard to larger issues such as global warming and wars fought over oil and other resources, and in aid of corporate interests.

The blight of urban sprawl and the bleakness of a smog-filled and noise-polluted city seem like a high price to pay for what amounts to an obsession with "convenience" — or the impression thereof — and a certain kind of intellectual and physical laziness.

Looking for a particular kind of creative outlet that music wasn't providing at the time, and wanting to communicate his frustrations and feelings to the city at large, led Roadsworth to examine the spaces available for such expression.

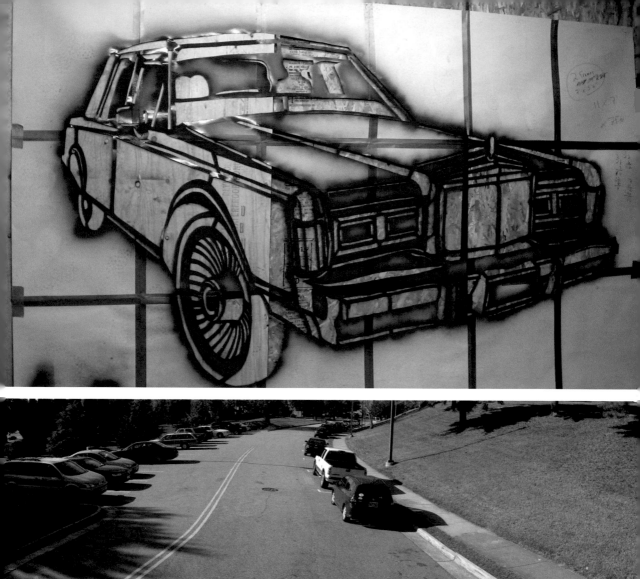
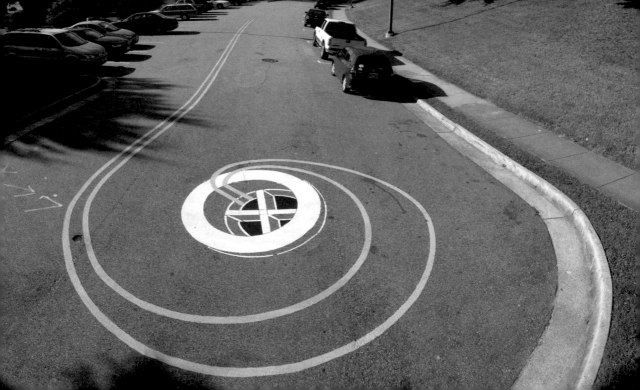

I wanted to test my own boundaries but also those of the space around me: the physical as well as the "legal" or "political" space.

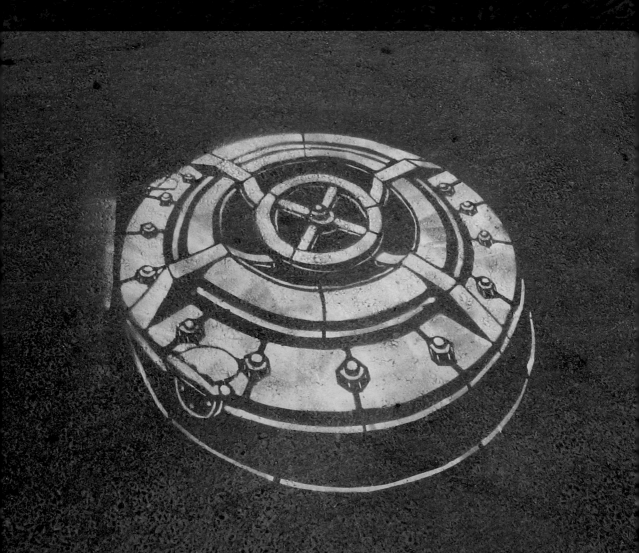

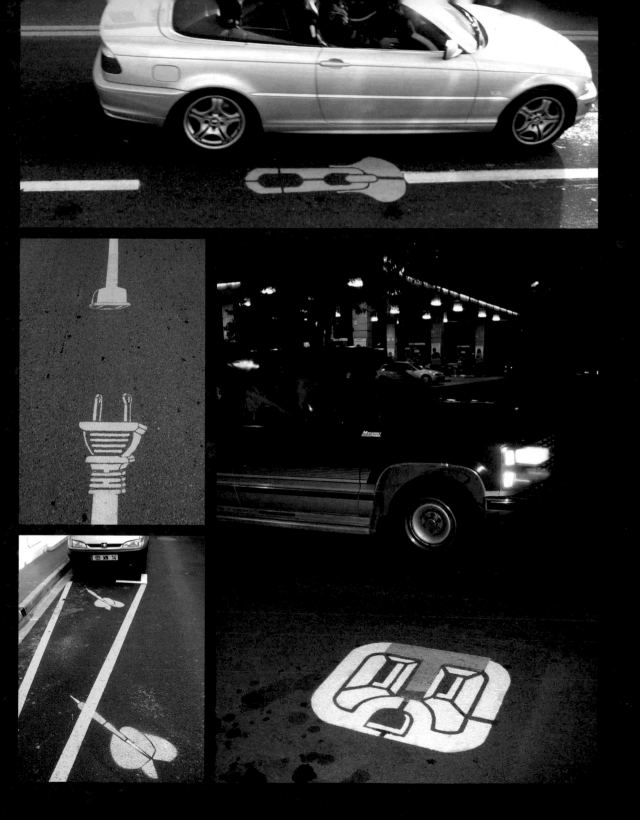

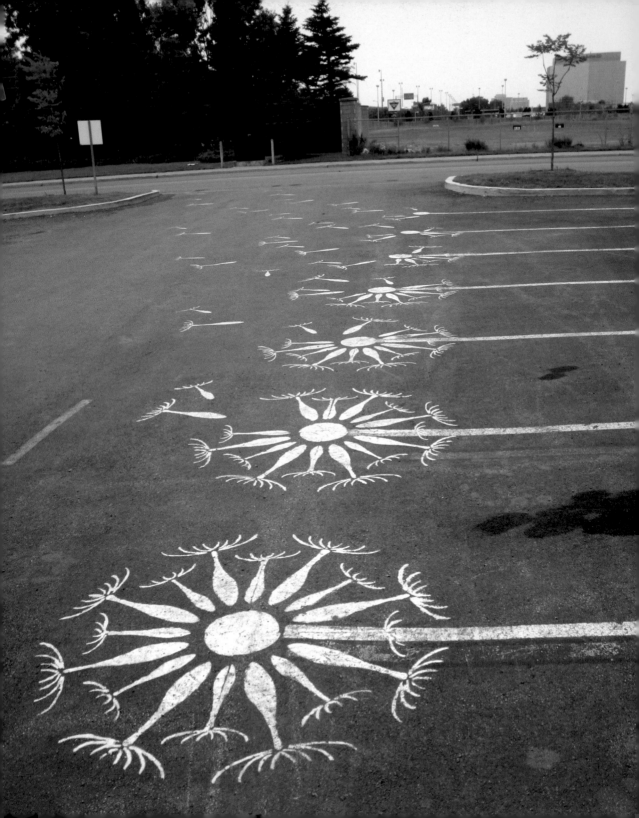

If capital__m is our religion, then the car
is one of its most potent relics and the
road its medium.

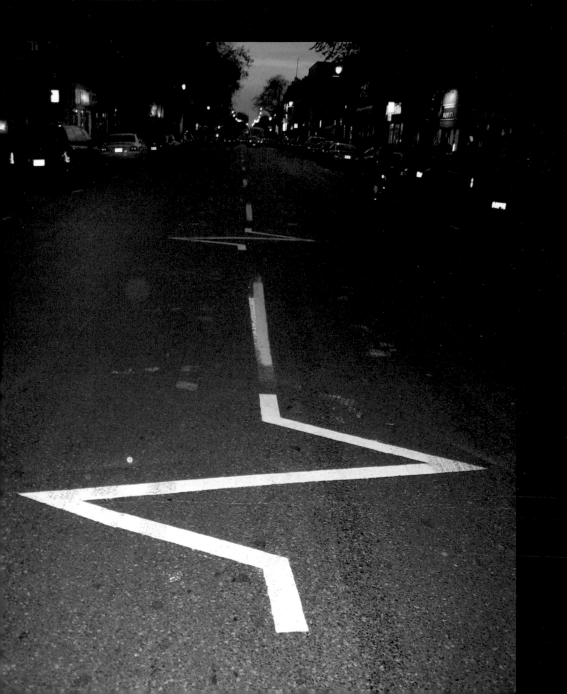

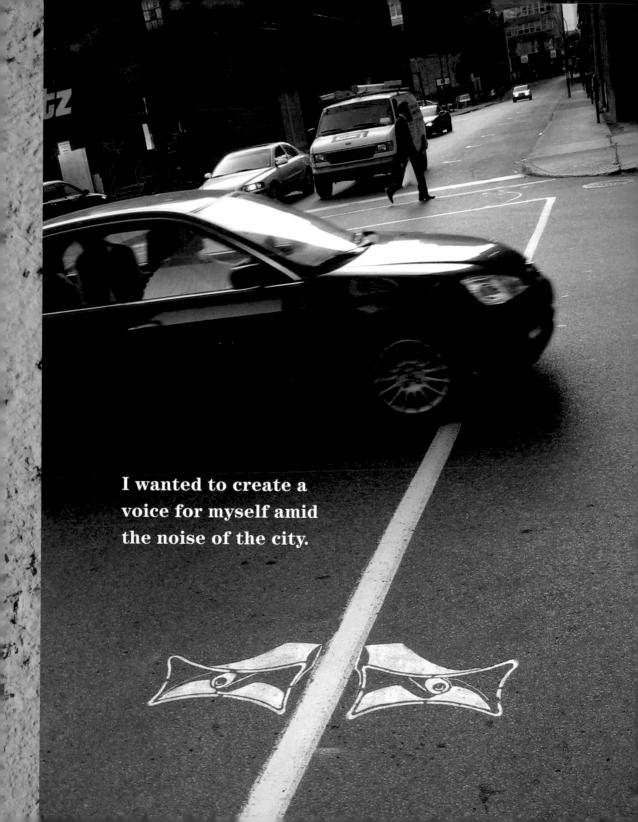

I wanted to create a voice for myself amid the noise of the city.

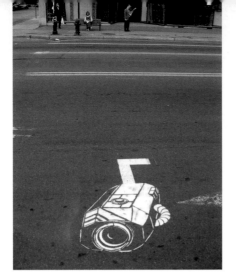

CATALYST

While Roadsworth had been musing on questions of car culture, consumerism, advertising and the use of public space, it was the aftermath of September 11, 2001, that galvanized him to move from intention to active expression. He felt he had nothing to lose, that the state of the world was such that any illegal action on his part would be innocuous in the grand scheme of things.

> I had a sense of righteous indignation about the way of the world, mixed with frustration, a desire for adventure, for something new, a wish to communicate to a general audience.

> My fear of consequences or judgment from society, my peers, was less than my fear for the world, my future and the future of humanity.

I felt that the North American response to 9/11 was inappropriate, in a sense. It was predictable — the encouragement to keep shopping and

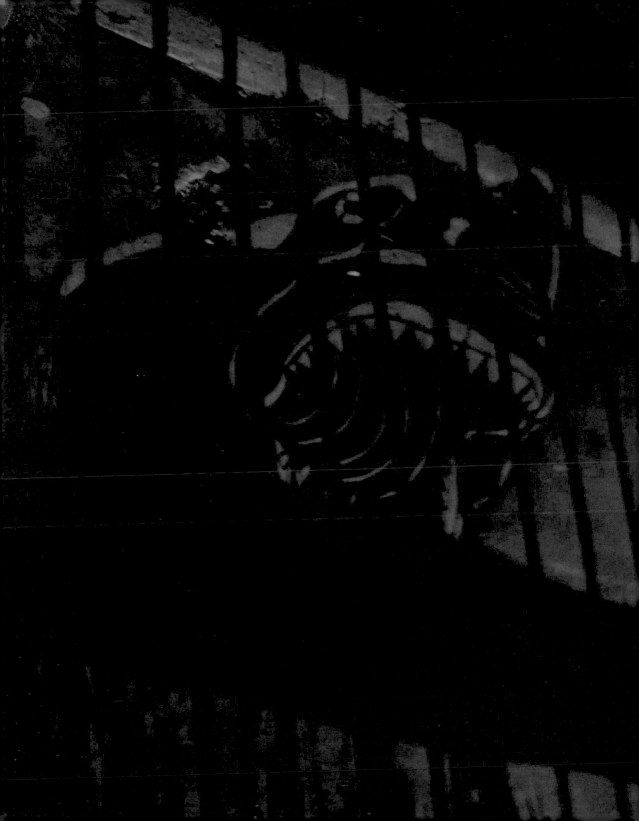

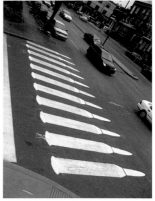

consuming gas and oil, the sentimentality and posturing by the American government. Fear-mongering was going on, and it was predictable sabre-rattling, without self-reflection on the part of the powers that be, and not enough questioning from the media. Added to this was my own skepticism with regard to the American government and its motivations for going to war, and a public that seemed ultimately willing to go along with what it was proposing. There was not enough questioning about the necessity of bombing and occupying an entire country.

This period confirmed for me that there was a certain element of insanity inherent in the status quo, and this provided the impetus and justification for breaking the law.

Legality and morality may often coincide, but they are not synonymous. I do not believe that what I do is harmful or immoral, especially when one considers the hypocrisy and denial of reality that seems — and certainly seemed at the time I started — entrenched in government, corporations and the mainstream media. When I started, I felt that pointing out that hypocrisy, critiquing the unsound and unconscious way we live, might help people — or else it would simply go unnoticed. After September 11, the world seemed in such a state of chaos, and there was so much fear and hatred being perpetrated by all sides and portrayed in the media, that I felt I had nothing to lose by expressing something artistically, and in a non-violent way.

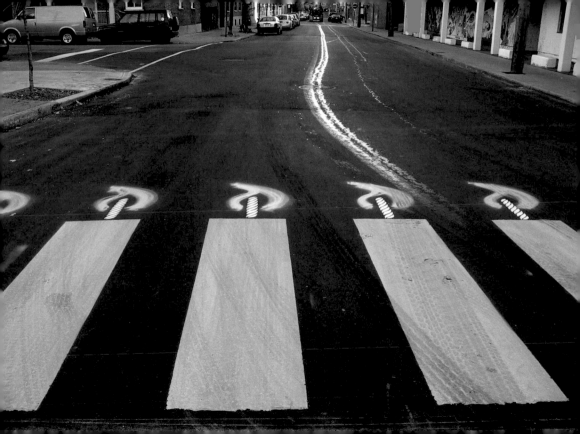

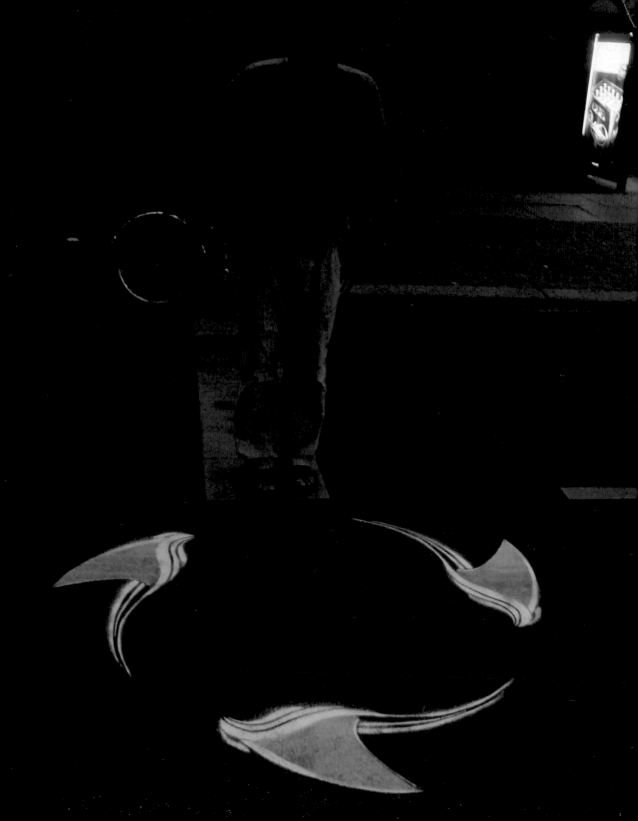

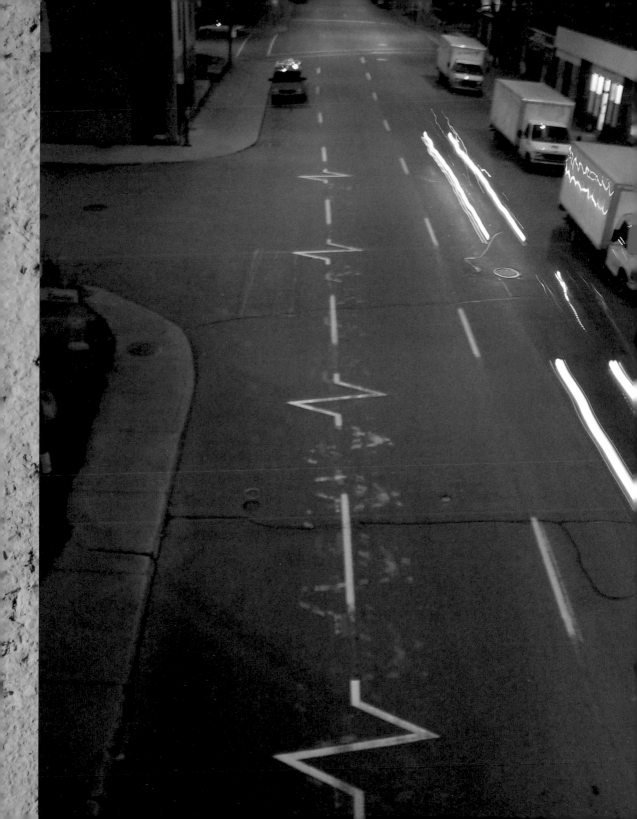

ROAD

In our culture, the road is sacred.

Roadsworth chose asphalt paint and the road as his media for a few reasons. He saw the road as a symbol of "civilization," and one of the first things to be laid down when a place is colonized and developed. It enables commerce, communication, capitalism. And it represents a pristine canvas, a blank slate calling to him to make a mark.

Roads are everywhere; they make up the matrix through which we operate. Their prevalence and uniformity make them unremarkable, but they are integral to the way we move and think. They engender a certain expectation of convenience and accessibility, but also represent a transitional state of being. The road is not a space on which to stay put; it requires constant movement. It is dead space in the sense that not only can life not persist there, but a road is, in fact, life-threatening. The road is a space between worlds, neither here nor there. It connects us but also separates us. The road is sacred and untouchable because it is so integral to how we live.

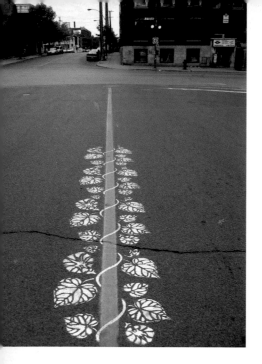

I've always been struck by the amount of graffiti that exists in most cities — though not on the roads or sidewalks. This has a lot to do with a perceptive bias that prefers looking at things on a vertical rather than a horizontal plane. Or the fact that most graffiti writers and street artists want to "get up" where they're most visible and where their work is likely to last the longest. Or maybe it's because there is something undignified about making your mark somewhere that will be trampled underfoot and run over by cars. I've always thought that it has something to do with the ubiquity of the street and the fact that it is both sacred and taken for granted. This mundane yet highly charged quality of the road represented to me a metaphor for the status quo and the kind of religious denial (blind faith, you might call it) that characterizes it.

The fact that the road is the medium through which car culture expresses itself made it an obvious target.

And road markings called to me. They represent the language of the status quo — clear, confident, blunt, authoritative, uniform, repetitive, standardized, universal, homogenous, politically correct, inoffensive, leaving nothing to the imagination, unquestioning — and I wanted to subvert that language in an effort to reveal the absurdity of it, and to imvest it with satire and poetry.

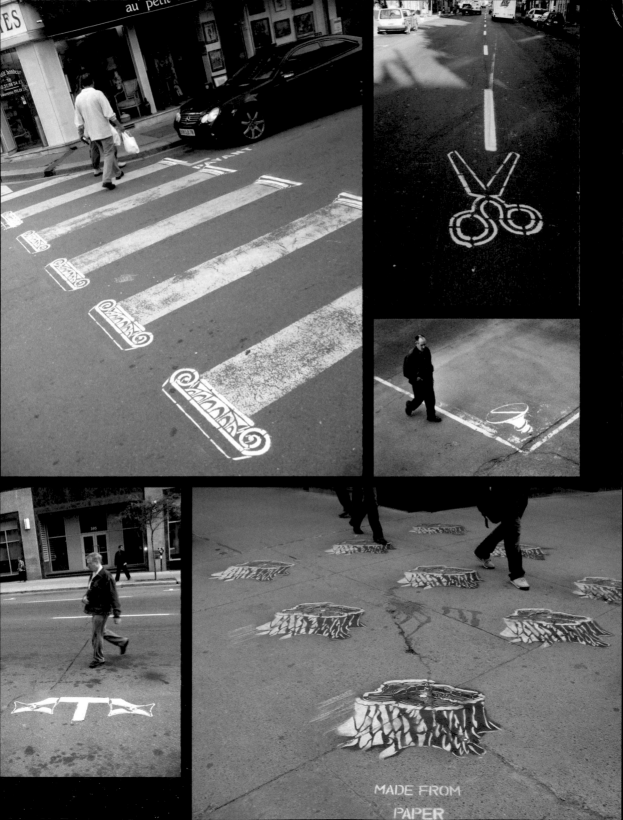

MADE FROM
PAPER

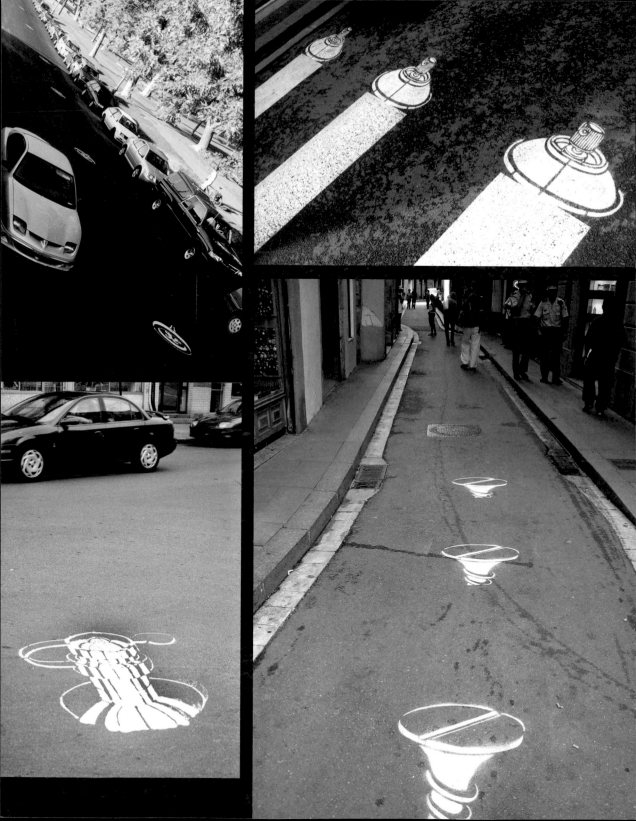

At first Roadsworth used cardboard stencils, road paint and a brush. It was messy, stressful work (cars could run over the cardboard before he had finished and ruin it; the stencil could blow away). He moved on to spray paint and Masonite cut with a circular saw. This enabled him to put a stencil down and walk away from it, confident it would stay in position.

Using a stencil as the basis for his imagery made sense. It is the most efficient way of faithfully reproducing a sketch or drawn image to another surface, and from there into another context. It allowed Roadsworth to repeat the same drawing, without variation, a number of times. Of course, it was crucial too that he be able to execute the pieces quickly.

> The basis of any stencil is a drawing. The creation of a stencil is a refinement of the drawing, which allows me to carve out volume, to thicken or thin out a line, to "redraw" a curve. It is akin to sculpture, which also deals with positive and negative space. Cutting away cardboard or Masonite, which has a certain volume, is a subtractive process similar to a sculptor cutting away stone.

> I would generally develop a concept based on a recurring aspect of the city's infrastructure, such as a sewer cover, sidewalk pattern or road marking, so that I could repeat the piece in multiple locations. This usually began by taking pictures and dimensions from which I then created a stencil that could be integrated with the street.

When Roadsworth started, the only colours of street paint he could get from the hardware store were yellow and white, colours that stand out boldly against grey pavement. Yellow and white became his colour scheme, and made sense in the

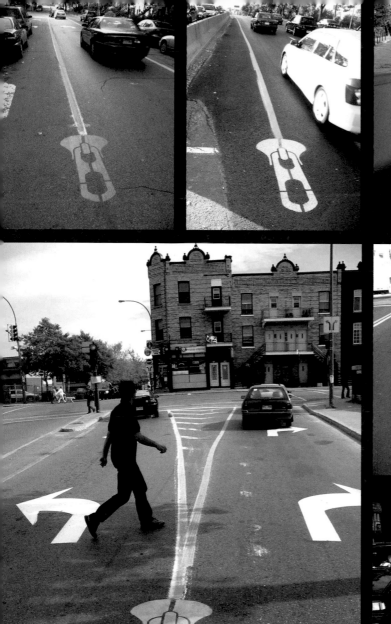
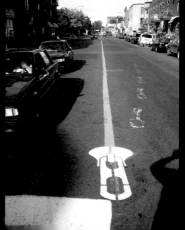
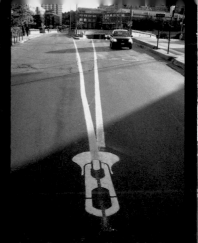
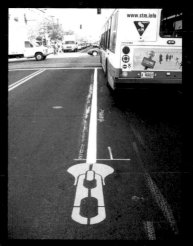

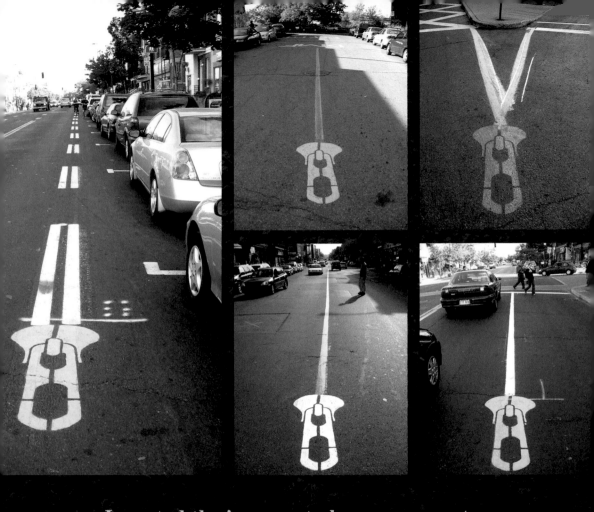

I wanted the imagery to be congruous, to suggest that what I did was possibly put there by the city itself. That's the kind of dislocation of reality I was going for.

context of his work. He was incorporating street markings, often trying to mimic the official, definitive tone of the road's language. He wanted his work to blend in, to be a part of the visual landscape that people expected.

He would complete as many pieces as he could, sometimes starting as early as eleven at night and working as late as eight in the morning, depending on the conditions on the street, how much traffic there was, how many people were around. He would repeat a design as many as ten times, or focus on a single, larger piece.

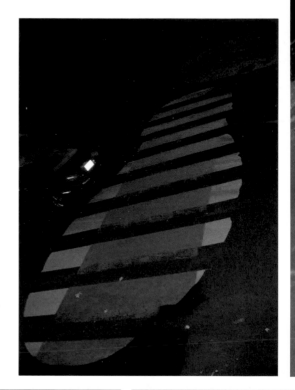

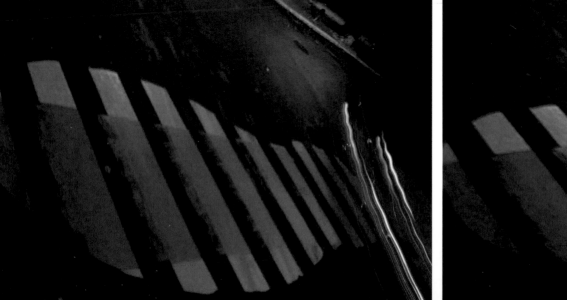

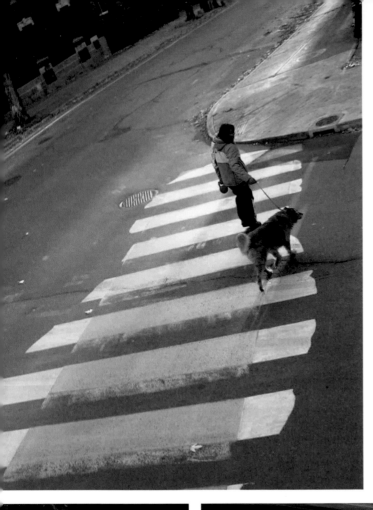

"North American Footprint" was risky: it was big, it took all night. I like it because it's subliminal, and the crosswalk was transformed with a minimum of interference from me.

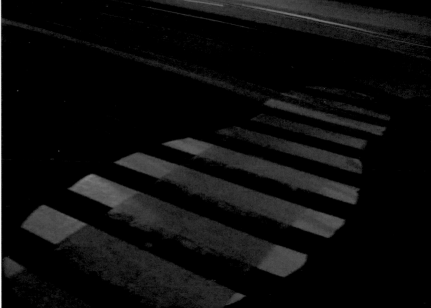

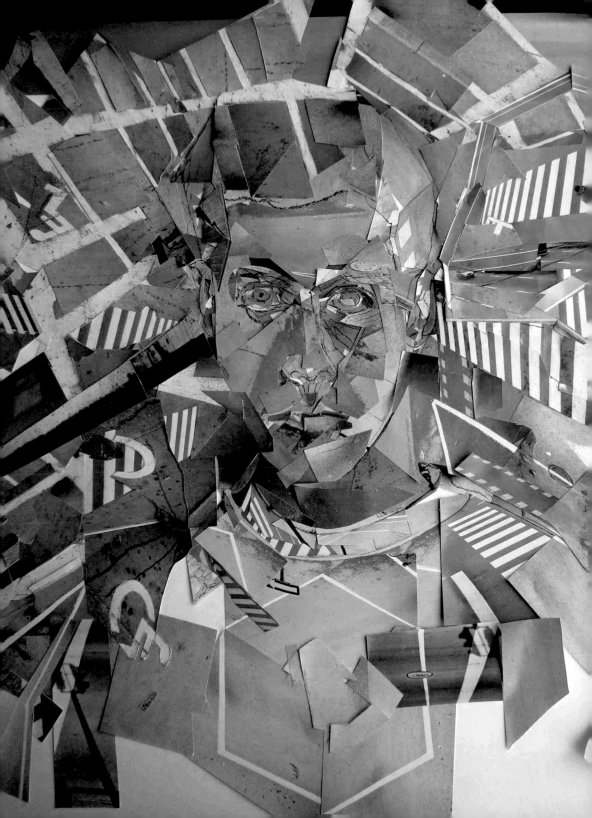

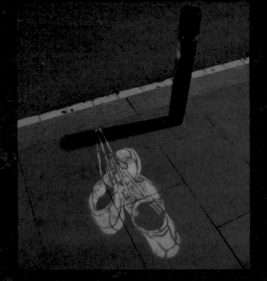

Street art is an expression of the relationship between an artist and the city.

A city has a soul, and every person in a city has a relationship with it. My own work is an expression of this soul-to-soul relationship.

Various elements — architecture, history, geographic location, culture, people, food, smells, atmosphere — give a city its distinctive character and imbue it, along with other intangible elements, with a soul. The recognition of a city's soul is personal and occurs through my experience of a city and is coloured by my own perceptions, feelings … my soul. I think the longer you live in a city, the deeper that soul connection is.

The city — its visual and aural intensity, its apparent indifference to the individual — motivated Roadsworth to make his own noise. He wanted to express in a satirical way his sense of alienation within the city; he wanted to say that he did not like, believe or buy into what the prevalence of cars and advertisements and commercial activity tells us our experiences are about.

Whether conscious or not, I think that establishing a connection with the city is the basis of street art in general. The number of people we come into contact with in the city on a daily basis — but with whom we rarely exchange more than a glance — and the volume of traffic, noise and activity, all contribute to a general sense of disconnection. (At the same time, there is something that comforts me about being surrounded by many people; and the cultural diversity of my city, for instance, enhances that experience of humanness.)

Street art makes the city feel more intimate, human, less impersonal. It attempts to overcome the sense of alienation people experience. Street art reflects a yearning for connection, sometimes with a

related and proportional to the desire for connection, and street art operates on that line between alienation and connection.

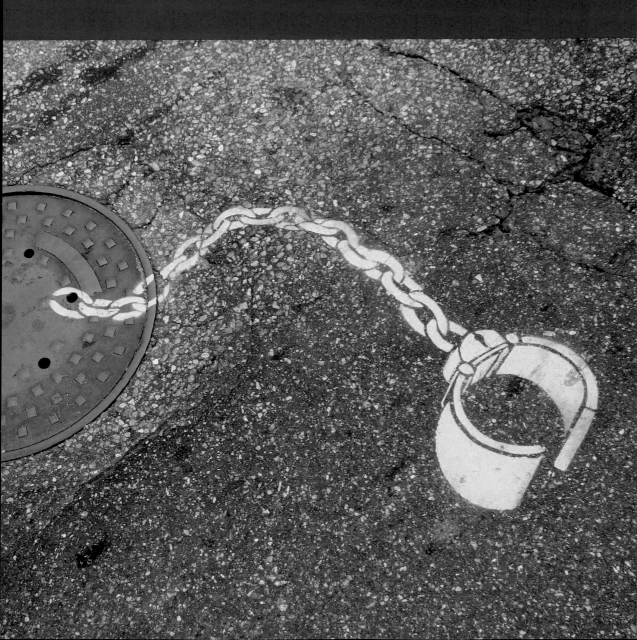

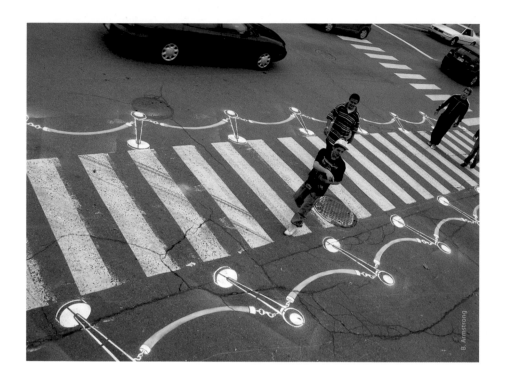

particular group of people (this could be said of many graffiti writers, who seem mostly to be communicating with other writers), and sometimes with a larger, broader audience.

In most cases street art exudes an energy that wants to connect with as many people as possible, and to communicate in an immediate way. It bypasses the art world, the gallery, and addresses people directly. Anyone can have access to it, just by walking down the street.

I feel ambivalent about working in the city. The city makes me feel aggressive — but I love it. The aggressive energy, the competitiveness, can be exhilarating, exciting, can push you, elevate you. That same energy can also wear you down.

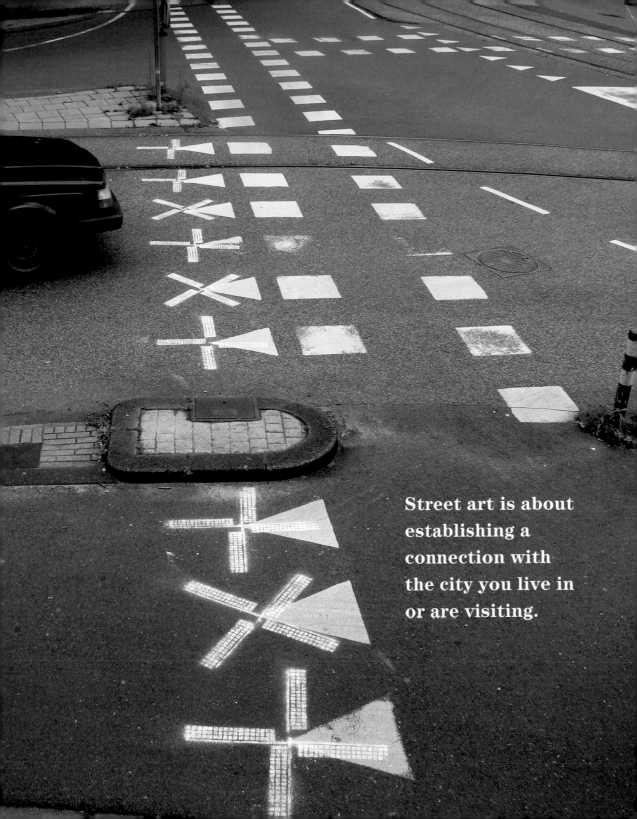

Street art is about
establishing a
connection with
the city you live in
or are visiting.

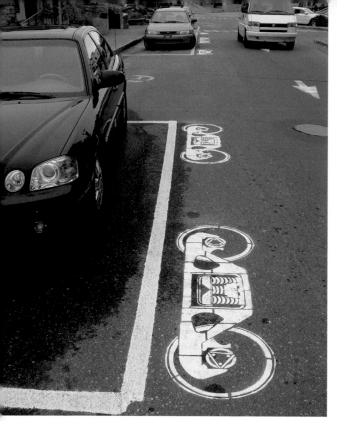
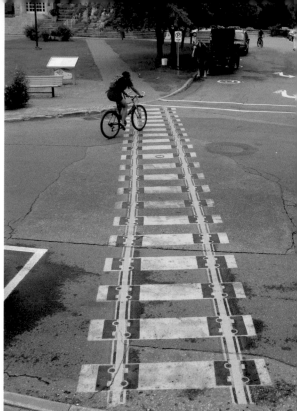

I grew up in Toronto, and people ask me if I would have done this in Toronto had I stayed. One thing that motivated me originally was the ugliness of the North American city, and the desire to inject some life, some humour and visual interest into the urban landscape. Toronto possesses that ugliness, and that sleazy corporate tone we feel steeped in thanks to ugly advertising on the streets and TV.

It's rare that I go to a city that I'm not inspired to explore. Berlin, Amsterdam, Lisbon, Barcelona, Istanbul, Belgrade, New York, London, Paris, even L.A. — which I never imagined I would like — all have an energy that inspires. When I go to a new city, I tend to walk long distances, as travelling by foot is the way to get to know it most intimately.

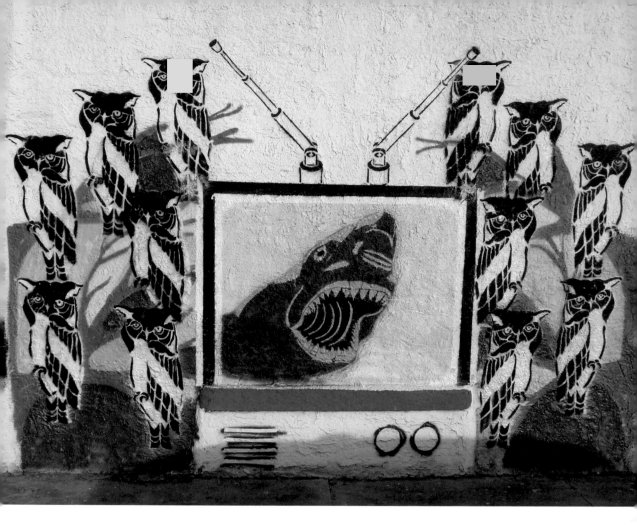

Connection is deeper with the city I live in. When I'm in a place I'm familiar with, ideas suggest themselves in a way that doesn't happen in other cities. When I've done work in foreign cities, my yearning for connection is directly proportional to my sense of alienation—and expresses itself more urgently, but more clumsily as well.

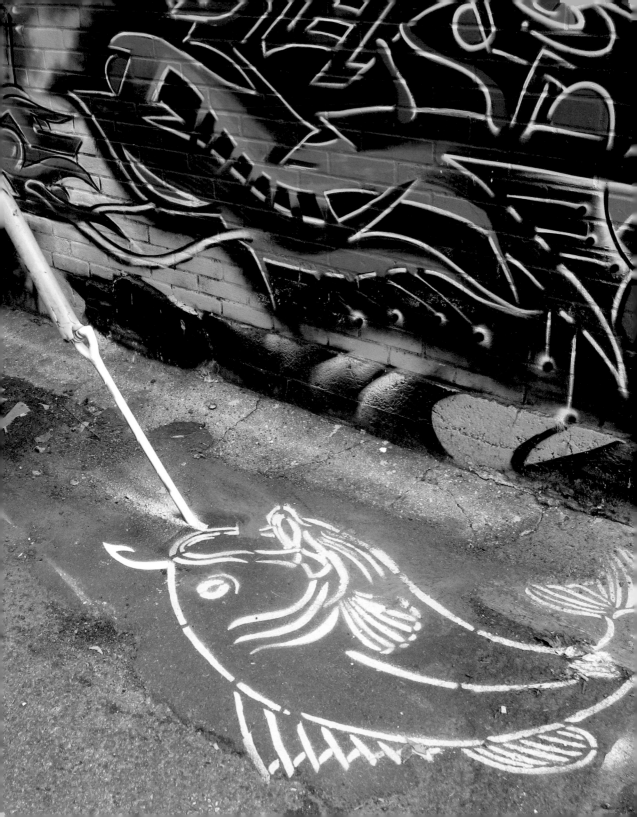

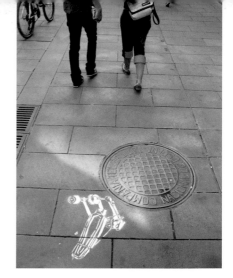

For a short period Roadsworth signed his pieces with "RW," though he quickly realized it was foolish to do the police-work of attaching work to name — and in any case, it was redundant as his style was so distinctive.

> I felt that by signing a piece I was saying, **This is art**, with all its pretensions — its historical and cultural baggage. I wanted my interventions to be free of that. I wanted people to wonder what it was they were seeing — as opposed to simply saying to themselves, Oh, this is that thing called street art.

"Roadsworth" is a moniker that situates him and his work inside graffiti culture and at the same time — because of its vaguely aristocratic ring — distinguishes him from it in a tongue-in-cheek way. It is identification with Andy Goldsworthy, an early inspiration; it also evokes Wordsworth, suggesting (visual) poetry of the street; and more directly, it points to the road and its value or worth.

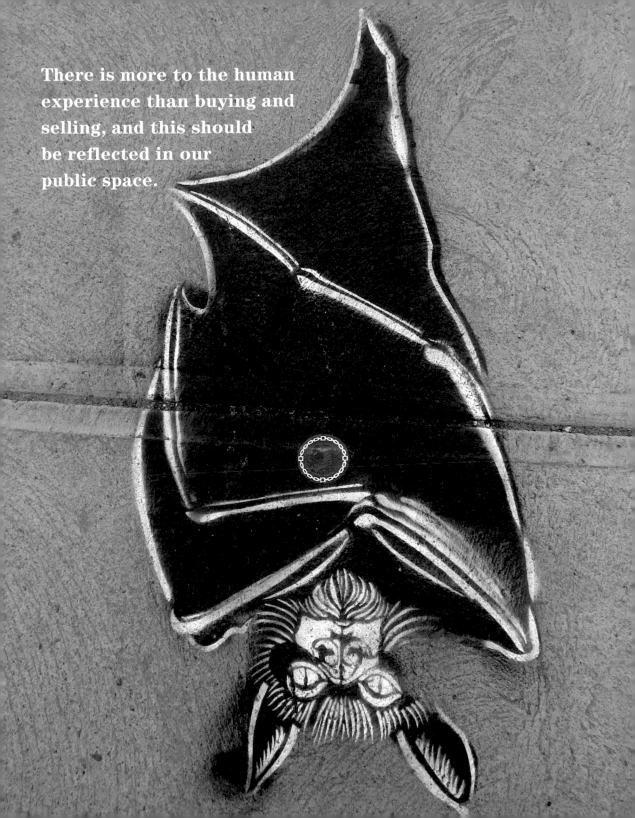

There is more to the human
experience than buying and
selling, and this should
be reflected in our
public space.

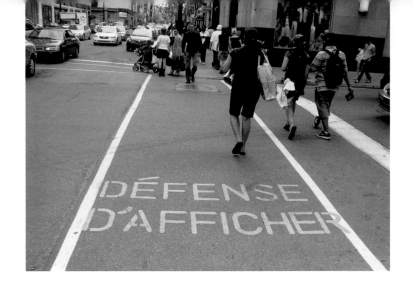

ADS

Roadsworth looked at his city and asked himself what is "free" expression, and how open to citizens are the spaces we label "public." He wondered how it is that a space where the city can express itself (through directives about parking and traffic movement and various prohibitions), where advertisers can make their pitches, and where members of the public are forbidden from making statements of any kind can really be called public. There is no genuine communication going on between people in this realm, except in strictly sanctioned ways, and only in one direction: from those with power, property or money, to everyone else.

If public space is the place where expression of who we are as a society occurs, then the predominance of advertising suggests that we are a society whose primary concern is buying and selling stuff. The fact that advertising is practically the only legal form of expression in public space, with the exception of occasional and usually corporate-sponsored instances of "public art," indicates that public expression is the purview of corporations and their bottom line, and not that of the individual—as one might rightly assume to be the case in a democratic society. The consumer's role is a passive

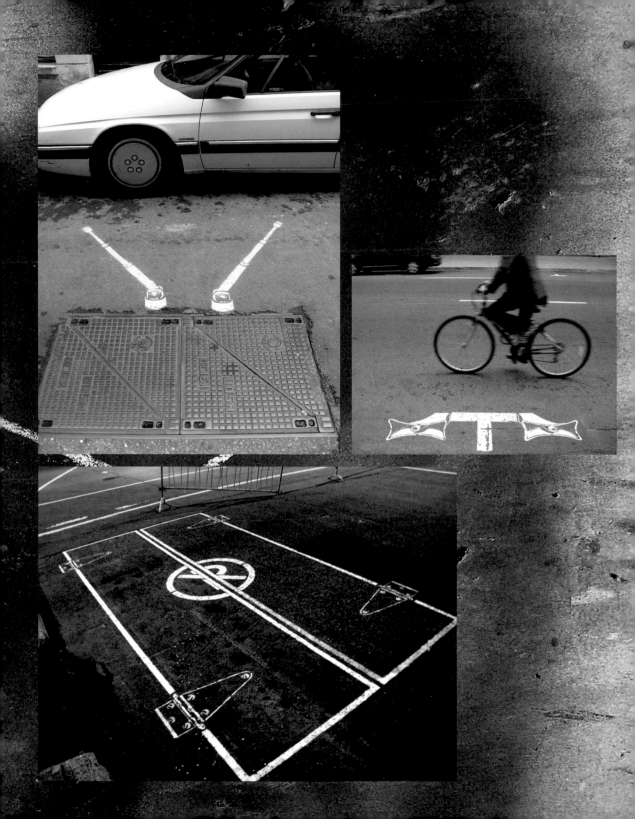

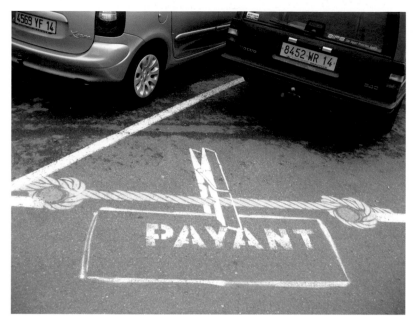
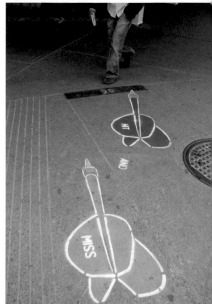

one, as advertising does not invite any kind of response or dialogue. Communication in public space is a one-way street, a monologue that, if responded to, results in fines or jail time.

We elect officials to manage the space that is for our common use. It makes sense to have laws governing the use of public space, but when corporations are allowed to erect massive billboards to advertise their products while local bands or individuals are fined for putting their 8½ × 11 photocopied posters on telephone poles, it is clear that "democracy" is a term used only loosely.

A society that says it believes in the notion of freedom of expression and the rights of the individual should tolerate individual expression and provide the space for it.

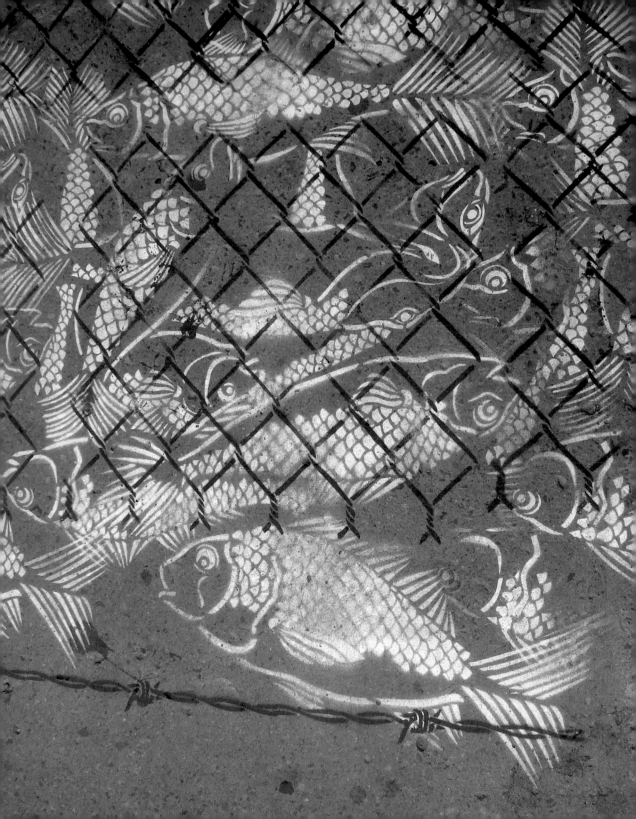

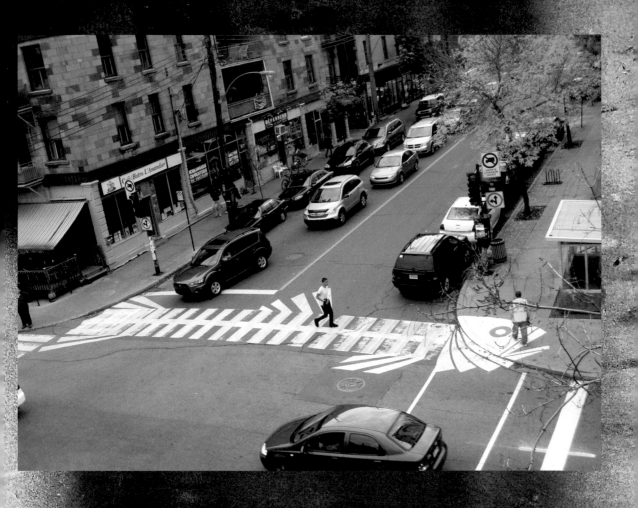

Maybe the closest we have come to
democracy is the democracy of money.
In theory anyone can get a hold of it,
but whoever has most of it gets to talk
the loudest and longest in public space.

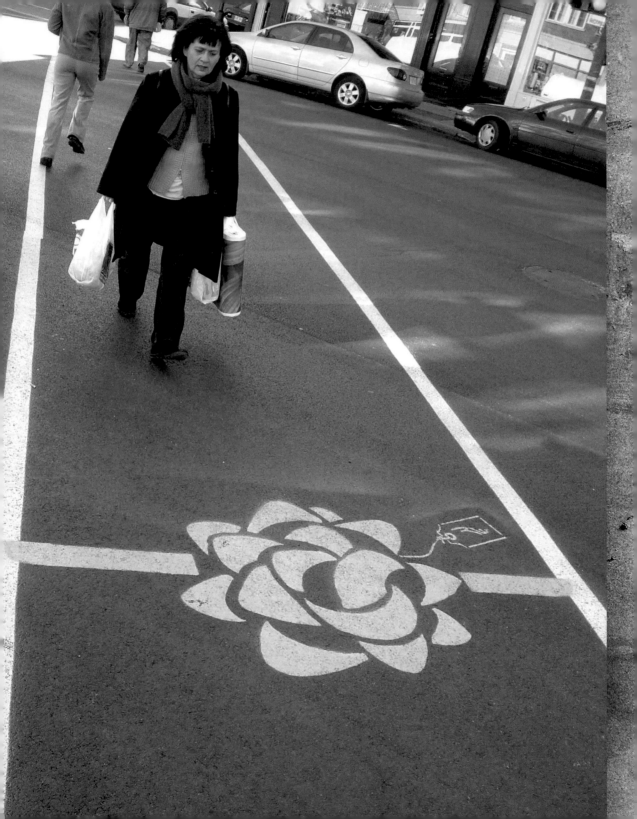

While letter-based graffiti was the dominant form of unsanctioned expression in Montreal when Roadsworth started, his intent, artistic, aesthetic and political, led him more naturally to a different form. Graffiti has traditionally been concerned with writing and language — using a name as a basis for form and colour, often manipulating or altering letters until they are unrecognizable, turning a name into a brand — its purpose to assert: *I was here*. Roadsworth's work grew out of an interest in form and colour; he wanted to express ideas, and to integrate those concepts with their environment.

The city is saturated with graffiti and I wanted to do something different than tagging, than writing my name on the wall. I wanted to do something I hadn't seen much of, something with more room for concept, design, subtlety.

Street art is a form of alternative media and one that is less subject to control than other media. It gives voice to the views of the individual, and allows for response to forms of media that already exist and that are officially sanctioned and controlled.

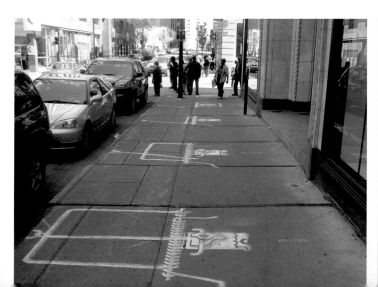
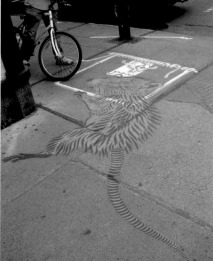

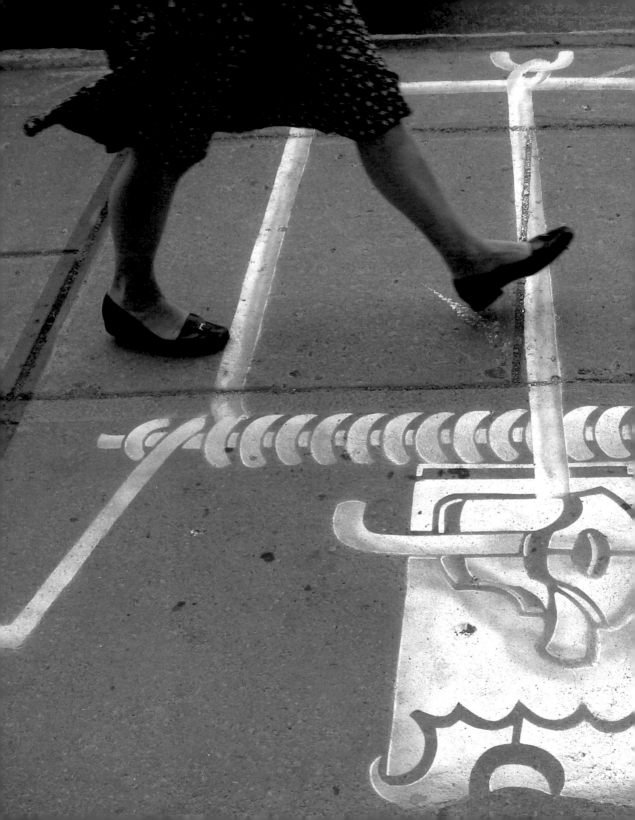

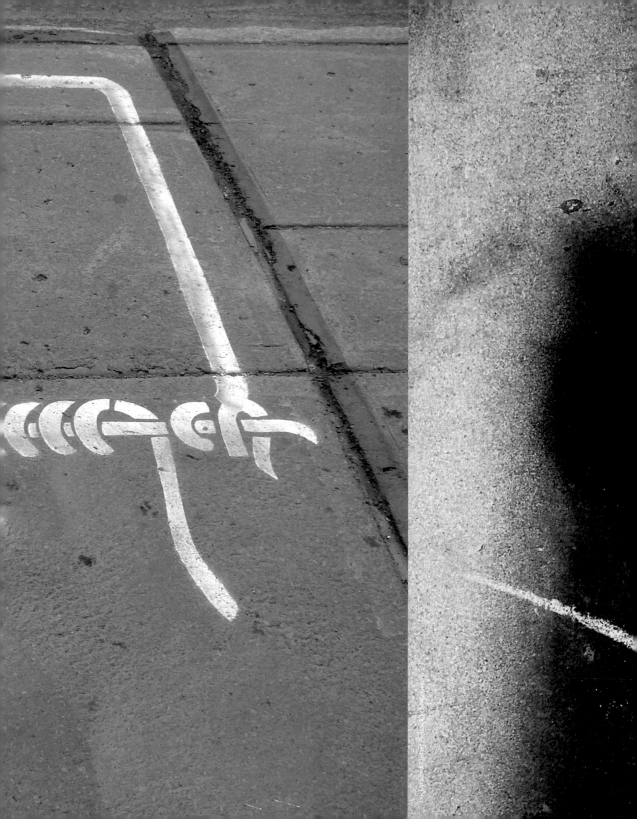

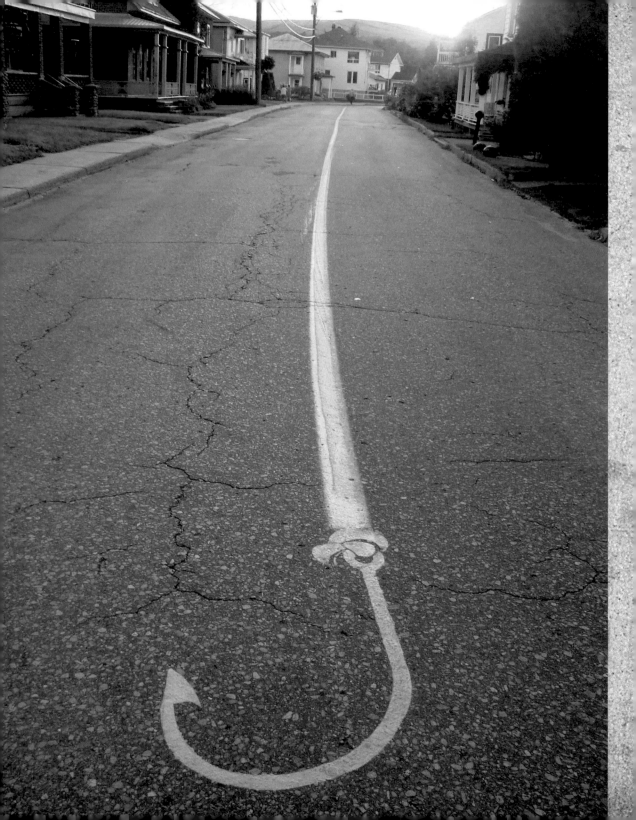

Olivier Blouin

SATIRE

While Roadsworth had something to say, he knew that the way he said it was essential to why he was doing it, to its meaning.

Instead of attempting to preach, I resorted to a form of iconography that is closer in spirit to satire than to protest. I lacked the confidence to issue slogan-like generalizations about issues I didn't fully comprehend, and I was aware of a personal degree of complicity in any case. An open-ended quality of expression lends itself more effectively to nuanced interpretation and dialogue than the "FUCK BUSH" or "OIL=WAR" kind of language that people are desensitized to.

My work is satirical, and sometimes a sarcastic response to the vapidity of culture. Sarcasm is not something I'm proud of—there's something too easy and contemptuous and affected about it—but it's an appropriate response to a certain falseness that's pervasive in advertising and politics. Advertisements only show the sterilized, shiny, good side of an object or situation. A lot of what I do has an advertising sensibility—as does a lot of street art.

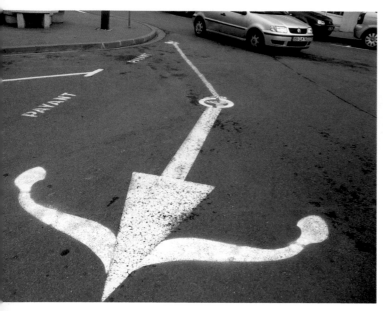

I think street art is the result of a generation of artists exposed to advertising who feel the need to respond and to participate in the public dialogue. Advertising itself has a very alienating effect, and I think a lot of street art attempts to challenge that.

Sarcasm feels appropriate because it speaks of denial. How can you respond to absurdity with seriousness or earnestness? Advertising is absurd, and so is sarcasm. It highlights the ridiculousness, with exaggeration.

As my process evolved, political concerns were eclipsed by artistic ones, and I often felt more inspired by the process than I did by the message I was trying to convey.

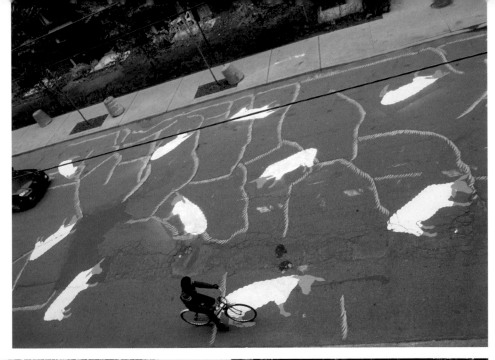

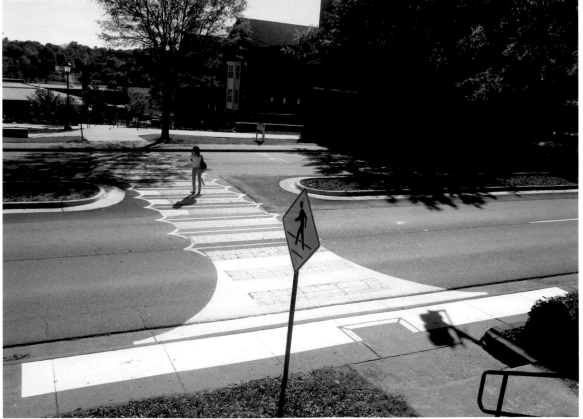

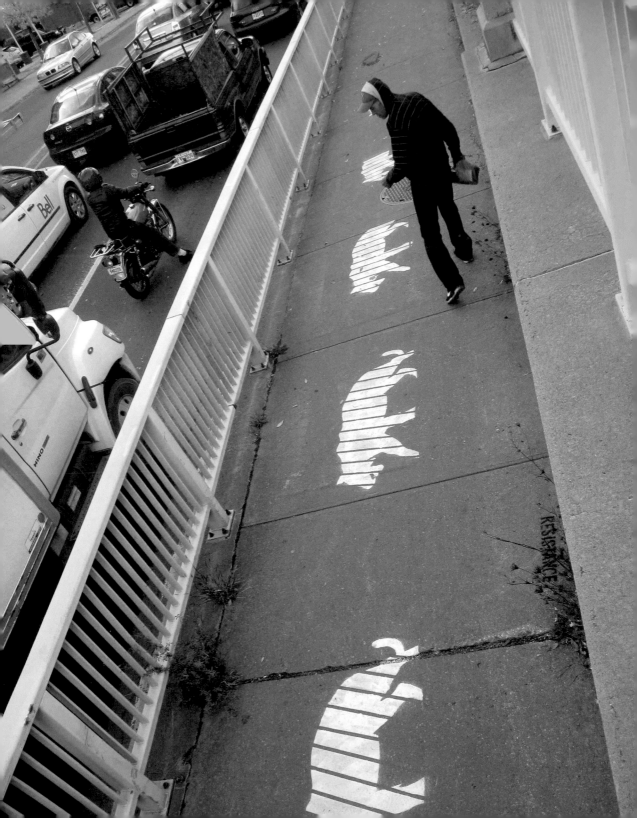

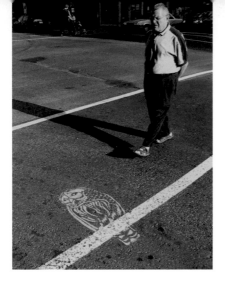

SUBTLETY

Early Roadsworth work is characterized by a subliminal quality, an integration of artistic intent into the existing infrastructure of the city. This necessarily results in an economy of form that is subtle, and sometimes not easily "read," at least immediately.

> I used street paint, and adopted the clean, iconic aesthetic that can be achieved with stencils to make my message one with the stark, functional, authoritarian tone of the language of street markings to produce an effect which is subliminal. I wanted to keep people guessing.

> The goal is often to create that disconnect, to jam, to throw the wrench in the matrix, to jolt the passerby from the autopilot he seems to be in. Part of the pleasure of doing it is creating the surprise. I imagine people's wonderment, an experience of mystery when they come upon something I've done. That's my aim.

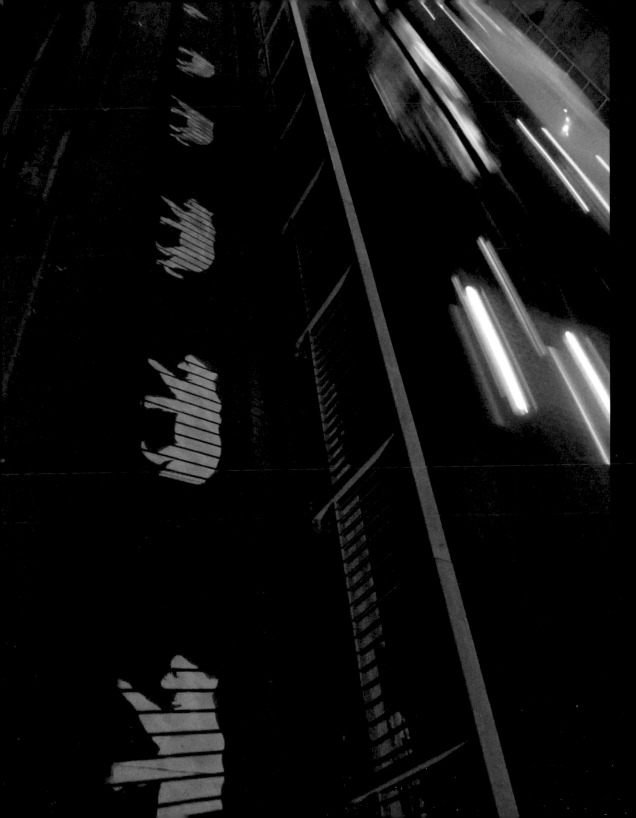

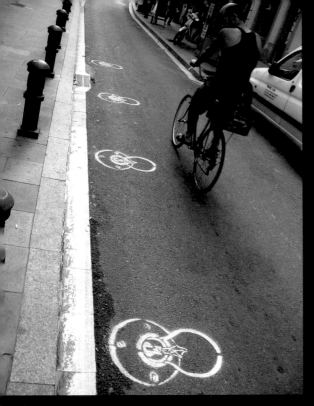

Using something that already exists, then adding or taking something away, without obscuring the original thing, appeals to me.

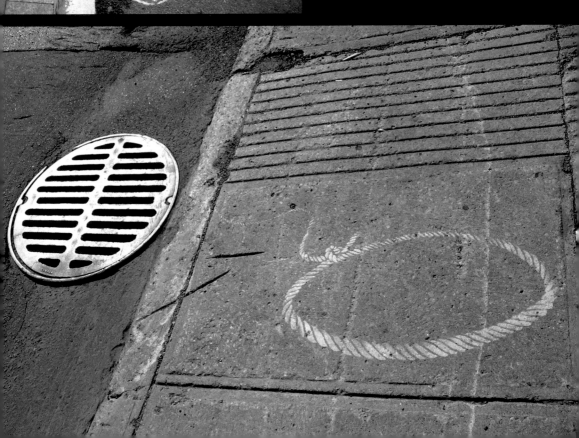

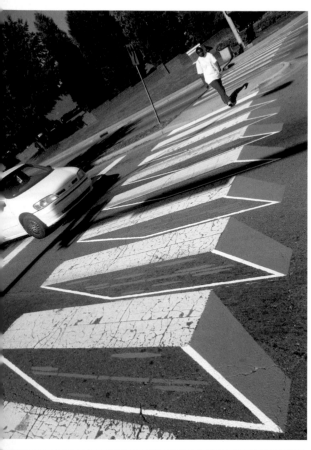

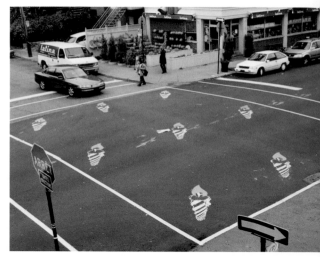

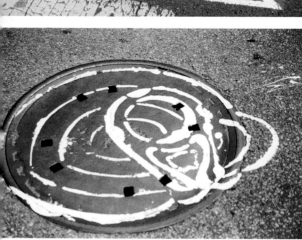

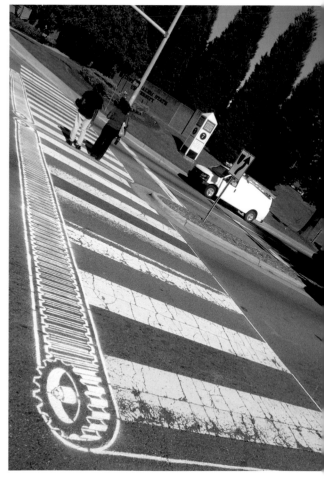

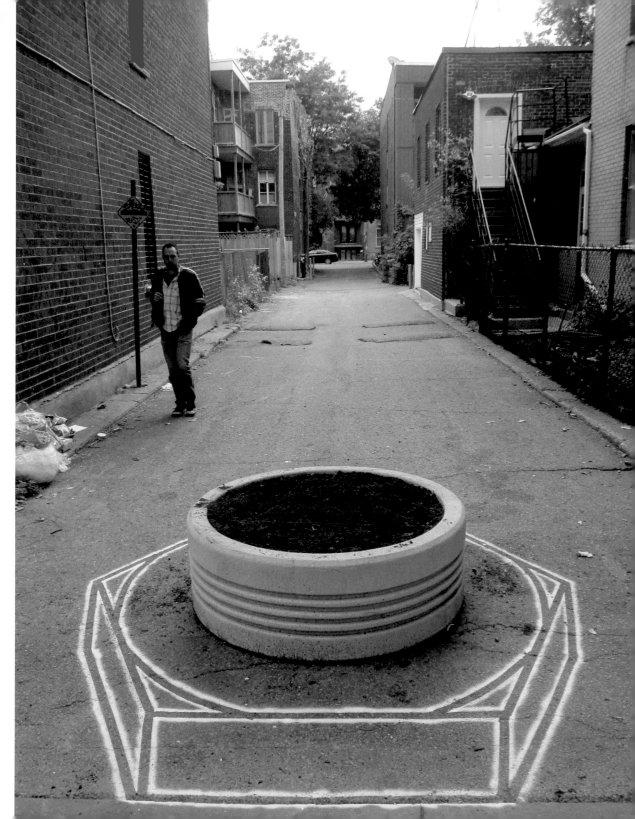

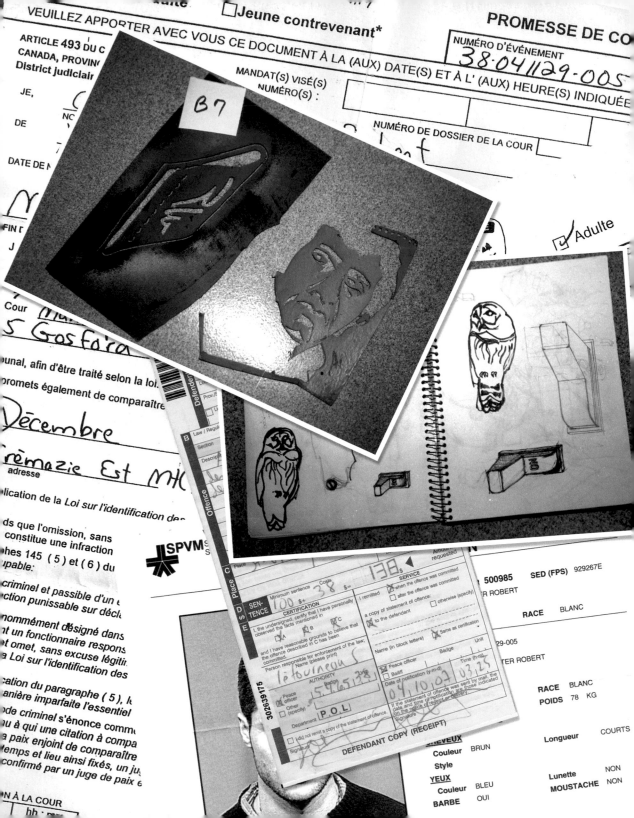

PROMESSE REMISE À UN AGENT DE
OU À UN FONCTIONNAIRE RESPONSABLE

D'ÉVÉNEMENT 041129-005

Masculin

l chef-lieu de la Cour munici

é au 775, rue Gosford

mars 2005 à 14h30

aw.

REVENU

A R R E S T

COMPRENDS QU'IL EST ALLEGUE QUE J'AU

(Grath

JY
12

$ et moins

Montréal

té, je m'engage, par cette promesse de comparaître ou cet engagement co

Quadrilatère Sauf pour travail (5198 Hutchison)

té de (juridiction territoriale désignée)

agent de la paix ou autre personne désignée)

Christophe-Colomb (Est) Restaurant Rahmi

adresse, d'emploi ou d'occupation;

mmuniquer, directement ou indirectement, avec

e, du témoin ou de toute autre personne)

specifie) ux autre personne désignée spécifie)

a (désignation du lieu)

orne - Rosemont (Nord), et Parc (ouest)

nformité avec les conditions suivantes: (celles que l'agent de la paix ou autre personne désignée)

ake (Sud)

ser mon passeport auprès de (nom de l'agent de la paix ou autre personne désignée)

e permettant me permettant

l'abstenir de posséder des armes à feu et à remettre à

om de l'agent de la paix ou autre personne désignée)

mes armes à feu et les autorisations, permis et certificat d'enregistrement dont je suis titulaire ou tout autre document me permettant

d'acquérir ou de posséder des armes à feu ;

à me présenter à (indiquer à quel moment)

de l'agent de la paix ou autre personne désignée)

ent de la paix ou le fonctionnaire responsable estime nécessaires pour assurer la sécurité

des capsules de peintu

à (nom de l'agent de la paix ou autre personne désignée)

de consommer :

(Stencils)

autres substances intoxicantes,

ordonnance médicale.

èder des

le peux être détenu sous garde et amené

être mis en liberté sous simple prom

aître ou lors de ma

un autre age

re un

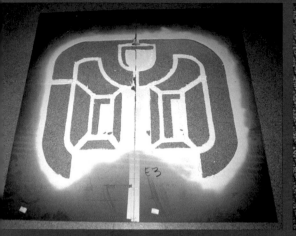

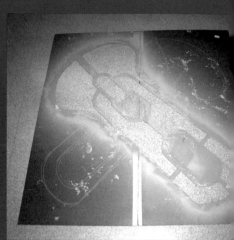
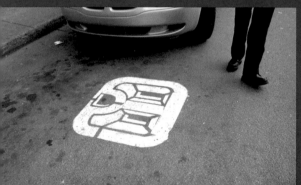

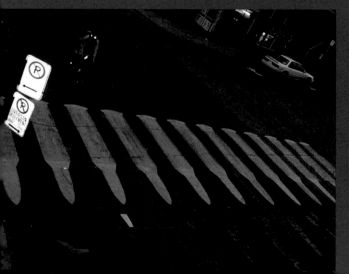
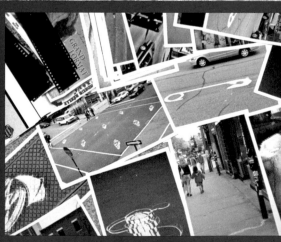

The arrest was huge. It changed my whole approach.

Roadsworth had been hitting the streets of Montreal for three years when things came to a sudden, possibly irrevocable, halt.

On November 29, 2004, at close to four-thirty in the morning, Roadsworth was arrested at the corner of Rachel and St-Denis streets. While he was in detention, a search warrant was executed, his apartment was searched, and various items, including paint cans, stencils and photographs of his work, were seized. This veritable orgy of evidence would help link him to a large number of the pieces he had produced over the previous three years. He was charged with 83 counts of public mischief (though the charge was reduced eventually to 51 counts). If convicted, he faced possible fines of up to $250,000, jail time and a permanent criminal record.

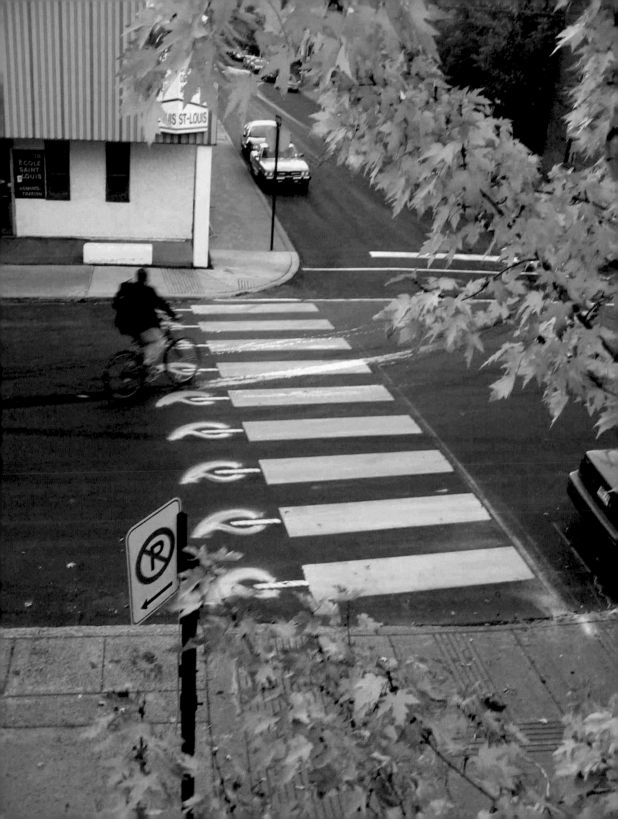

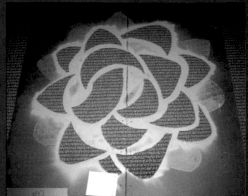
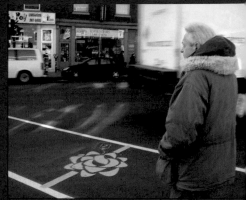

After the second incident, Roadsworth thought that perhaps he was done, that he shouldn't push his luck. But he couldn't resist.

By the time of his arrest, Roadsworth knew he was getting more cavalier, and therefore conspicuous.

I felt so confident, I had so much conviction about what I was doing. I think I was prepared for an arrest to happen.

I knew it was illegal, what I was doing, but I felt—and still feel—morally justified. There's so much crap out there we have to look at, that's sanctioned.

There was an addictive quality to the creative rush and in the act of execution. I felt "I can get away with one more." One idea led to the next, and I would think, "The next piece will be so devastating — even if I do get arrested, I will have been able to do this one, and it will be worth it."

I thought there was so much of my work out there that they wouldn't notice, unless I got caught red-handed. And I did.

I was in the middle of laying down a yellow Christmas ribbon when a police car approached. As soon as I noticed the car, I dropped my can and assumed my "innocent bystander" stance. I was some distance from the stash of paint cans, and the half-painted stencil, and they didn't seem to notice that — even though I had paint all over my shirt and pants. I somehow managed to get myself onto my bike and drove several blocks before being cornered by, I don't know, three or four squad cars, lights flashing.

Following his release from jail, he was not allowed to leave the island of Montreal, but was forbidden from entering a particular neighbourhood (where most of his work had been produced), except to go to the restaurant where he waited tables. This proved difficult as most of his life outside of work was conducted in this area. He could not possess paint cans or stencils, and had to report to a probation officer at intervals and be present at various court hearings.

My lawyer was impressed by the file of evidence that had been compiled, as well as the policeman-hours devoted to documenting it. I remember the night I got arrested hearing various comments

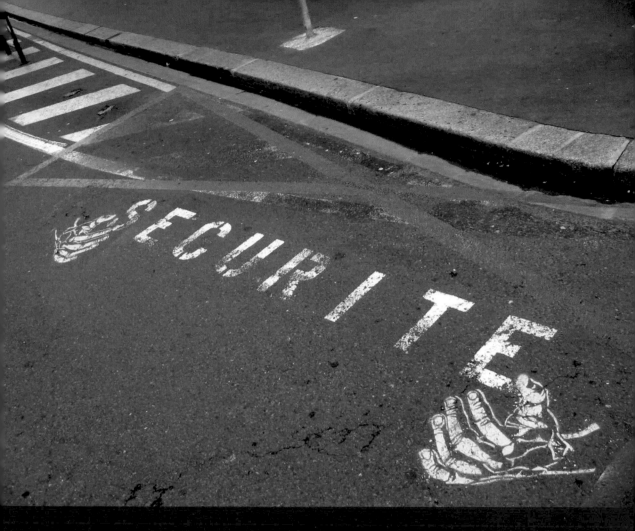

from different police officers at the scene of my arrest and at the
police station that suggested they had been looking for me. And the
inspector herself kept referring to a writer they caught from Ontario
who was banished from Montreal and who was on the hook for
hundreds of thousands of dollars in fines. Hard to know, but I had
the feeling they wanted to make an example of me... and wanted
me to know it.

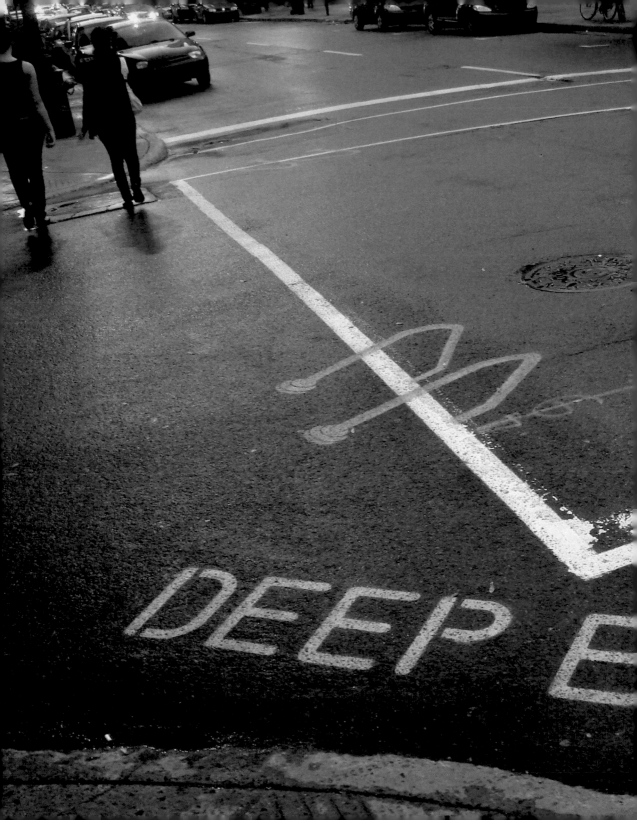

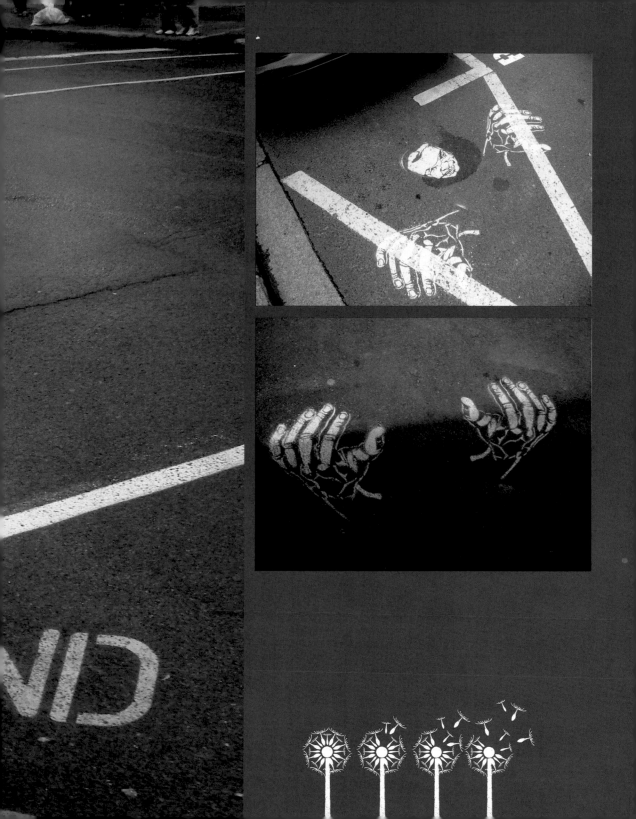

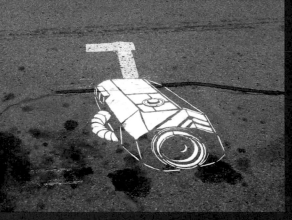

One of the arguments the city seemed intent on pursuing was that his work was a threat to public safety: people might get distracted, even misinterpret road markings, to dangerous effect.

"Public safety" is a compelling argument since people value their security above all else, but it is often a spurious one as there are many state-sanctioned practices that are much more dangerous to people's security than street art. What constitutes "security" is subjective and what fosters or threatens it depends on the point of view. Public safety is often invoked when justifying going to war or upholding gun "rights." It's also reminiscent of the charge that protesting war endangers the lives of troops. War endangers the lives of troops. An exaggerated comparison, but I think the basis of the argument is similar and almost as hypocritical. If public safety were the main concern, then there would be bike paths on every street to prevent the many cyclist deaths and injuries that occur every year, more protection for pedestrians and a serious effort to minimize car traffic in general. And if my street art constitutes a threat to public safety, then what of all the distractions that line the road in the form of advertising?

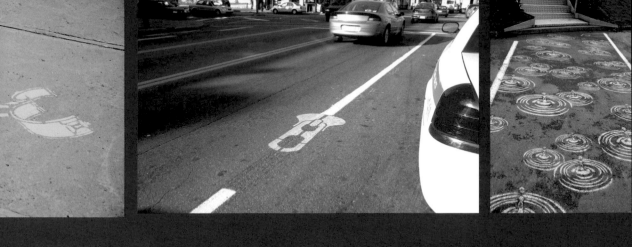

While Roadsworth was aware of the charged nature of his illegal interventions from the beginning, he thought of his work primarily as a project of artistic self-expression rather than as a form of civil disobedience. The arrest forced him to question how far he was willing to go to make of what he had done a kind of general protest in the context of the courts; or whether there was a way to stay true to his artistic intentions and not martyr himself in the debate over public space and who has a right to use it.

ROUGH ROAD ENDS F...

Artistic wink has b...
an urban whirlw...

ARTIST FACES 53 COUNTS OF MISCHIEF

Roadsworth says he wanted to make people
in Montreal think outside the concrete box

T'CHA DUNLEVY
THE GAZETTE

It's all fun and games till some-
one gets arrested.

Roadsworth, whose real name
is Peter Gibson, is in the middle
of a bittersweet whirlwind. On
the one hand, he is facing poten...

is a criminal investigation.
Gibson's trial is set for...
29. He is represented by
Pierre Desmarais, of th...
Grey Casgrain, home to
human rights lawyer...
Grey.

"It's a big case, in th...
that there are a lot of cha...
ing laid against him...

...RT URBAIN EN QUESTIC...

...sa vie, Peter Gibson sert des boissons dans un
...our vivre, ce jeune homme, maintenant connu
...de Roadsworth, fait de la peinture, de la
...e la sérigraphie et de l'art urbain. Pour avoir
...es éléments de signalisation dans les rues de
...en leur ajoutant du lierre, des barbelés et des
...et artiste, originaire de Toronto, devra bientôt
...à une cinquantaine de chefs d'accusation. Débat
...ce urbain.

...IRARD

...t pas ici du geste des graf-
...des traces d'art public sub-
... et associé aux sculptures
...les parcs et les édifices. Il
...t question d'un langage ar-
...qui utilise comme toile de
...space urbain et qui se mani-
...ans l'accord des autorités.
...moi c'est clair, ce n'est pas de
...blic, c'est de l'art urbain, dit
...cialiste de l'art contemporain
...Grande. L'art public, ça fait
...d'abord, pour quel public ? »
...on côté, Peter Gibson dispose
...dénomination toute person-
...pour désigner son travail. « Je
...re dire poésie de rue. Ça peut
...tre prétentieux mais comme il y
...a langage et un côté satirique,
... moi c'est cela. »

...phénomène de l'art urbain s'est
...ablement fait sentir dans les an-
...s 60 avec l'avènement des perfor-
...nces. Mais pour Louis Jacob, pro-
...eur au département de sociologie
...ilt difficile de retracer

« arrêt » du centre-ville. L'artis...
originaire de Winnipeg, effaçait
« r » et le « e » du mot arrêt a...
une pellicule pour faire apparaîtr...
vocable art. « Je veux amener l'a...
où il n'est pas normalement. l'...
important que l'art vive dans la...
Je fais cela pour partager des...
avec les gens, pour leur arrach...
sourire. »

Ce sourire, Pierre Allard, du...
pe Action terroriste socialeme...
ceptable (ATSA), l'a eu en vo...
travail de Roadsworth. « Le...
où j'ai vu ses fils barbelés...
dans la rue, ça a fait ma jo...
dit-il.

L'espace urbain est à tout l...

L'utilisation de l'espace u...
jamais donné lieu à un vrai...
plupart des interrogation...
aussi vides qu'un terrain...
centre-ville. « Tout le mo...
pe à l'art public, dit le c...
Léo Rosshandler. Ce qui...
c'est de voir qu'on blân...
comme Roadsworth et o...
ne nous demande ce...

devrait savoir
est invisible.
pas refuser un
ter d'autres
Soyons franc...
une étape ve...
miste, les su...
commercial.
exactement
artistes ne
qu'on le pe...
provocateur
sur Armand
le feu, et pl...
re Dialogue.
Peter Gib...
me difficil...

Roadsworth | Art or va...

CONTINUED FROM D1

"I hate when people junk up
this guy with useless (graffiti)
tags," Mayer said. "But these
things are so clever, I just pre-
sumed they were commissioned
by the city. The zipper is bril-
liant.

"I really hope they don't pun-
ish this guy beyond all measure.
An arbitrary judgment is not
what we want. It's not vandal-
ism. You can see the public out-
cry, and not just from students
and youth groups."

History is replete with artists
who have challenged social
norms, according to Mayer, who
is organizing a retrospective of
New York artist Jean-Michel
Basquiat (who had his own run-
ins with the law in the early
1980s) for the Brooklyn Museum
in March.

"Tons of artists have had trou-
ble with the law. Artists see
themselves, like journalists, as
the conscience of society. There

"The government and officials
are always trying to manage the
public's expression. It's like
some arrests in protests. These
are not criminals. They are peo-
ple with values who express
them in ways that get them in
trouble."

While he is not at liberty to dis-
cuss details of the case, Des-
marais hopes that cooler heads
will prevail.

"I'm going to try to see with
the city what their goal is in
pushing this so hard," he said.
"It's very early in the case. I
wouldn't want to give anything
away (in terms of our defence).

"The big thing is 'mischief,'
which is the destruction of pub-
lic property. Of course, the ques-
tion of whether this is mischief
is the central point."

The city of Montreal is not
commenting on the case, as it is
still before the courts, administra-
tion spokesperson Darren
Becker said.

Richard Côté, a political aide...

Roadsworth's art is stenciled

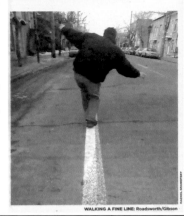

NEWS PUBLIC ART

Roadsworth R.I.P.

Stencil artist Peter Gibson reflects on his sudden
fame and the death of his alter ego

WALKING A FINE LINE: Roadsworth/Gibson

nt store) – enough is

the serious nature of
es, a shell-shocked Gib-
nitially tentative about
ublic with the news.
k the baton, contacting
outlets, setting up a
orth info page on the
llery blog site and en-
people to write letters
and the media.
y is a bunch of fascist
ts who don't know
're talking about,"
d, matter-of-factly.
, we can convince
error of their ways."
voir of any art vs. vandal-
'est . Hand says the an-
ven-
aire. 's art. I was talking
e est iss (of Toronto's Mu-
nfor- ntemporary Canadi-
arché other day. We were
c'est hen it is vandalism,
é. Ces id the punishment
naifs t's art, the punish-
un ton fit.
uvrage ant to live in a city
uer avec hrow artists in jail.
rt Natu- e mark of a democ-

pas, mê- 's not generally a
lui don-
aine re-
station

lism?

EN MCINNIS THE GAZETTE
Iscape.

SUPPORT

Chris Hand of Zeke's Gallery in Montreal found Roadsworth a lawyer, and set up a
"Save Roadsworth" campaign. Several members of the arts community in Montreal
(among them Yves Sheriff of Cirque du Soleil and Philippe Lamarre of *Urbania*
magazine), as well as in other parts of the world (such as Wooster Collective in
NYC), came to the defence of Roadsworth, and once the media publicized his case,
it became clear that Montrealers in great numbers, who had seen and enjoyed his
work, were also supportive. Letters were written, petitions were signed, public
figures spoke out in defence of Roadsworth and the media seemed behind him.

On January 17, 2006, the City of Montreal settled out of court. Roadsworth had
to pay $250 in fines and perform forty hours of community service. His sentence
required him, in fact, to devote his talents to a project of his choosing in the Plateau
neighbourhood of Montreal — a neighbourhood he had been accused of heavily
vandalizing. It amounted to a slap on the wrist.

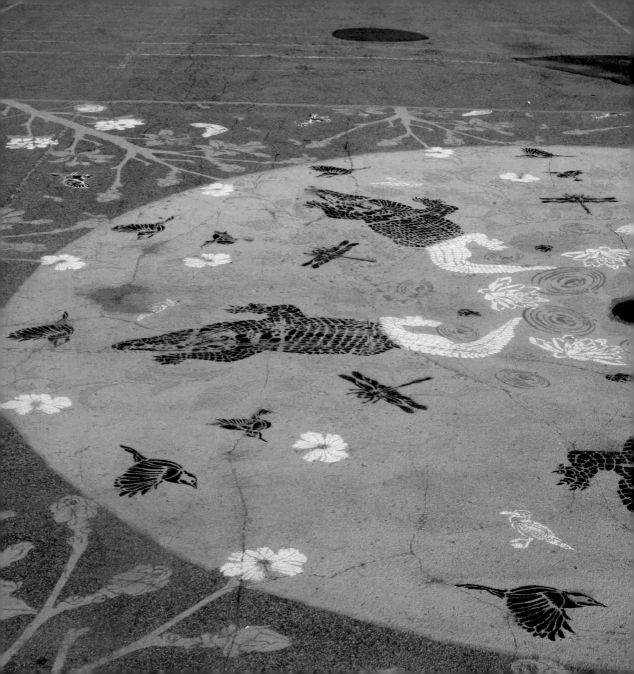

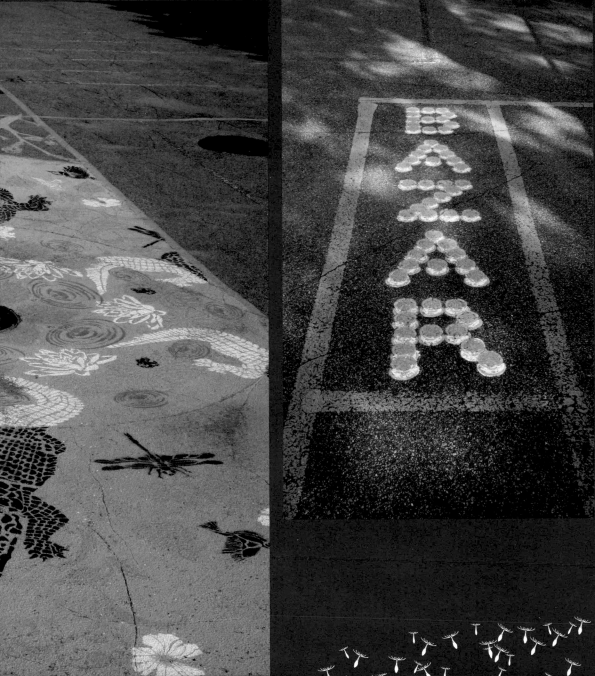

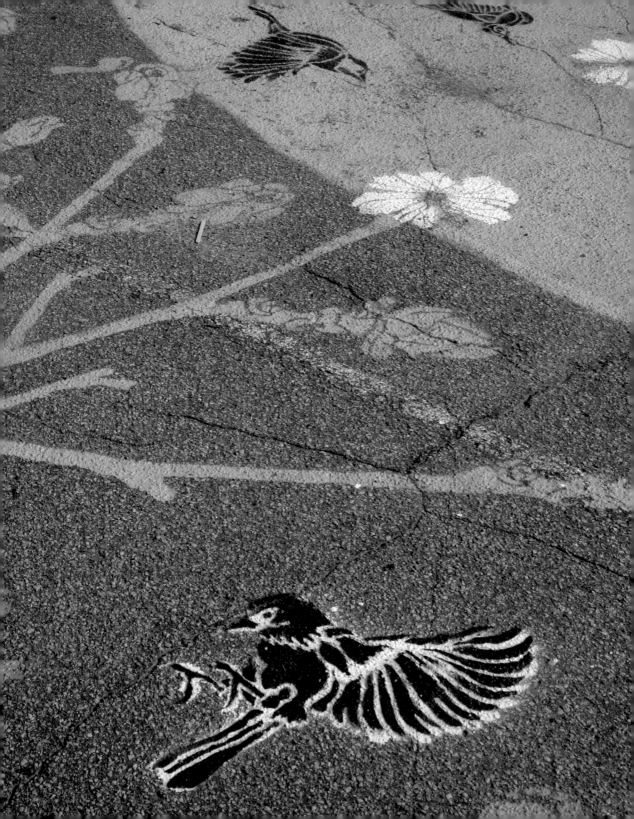

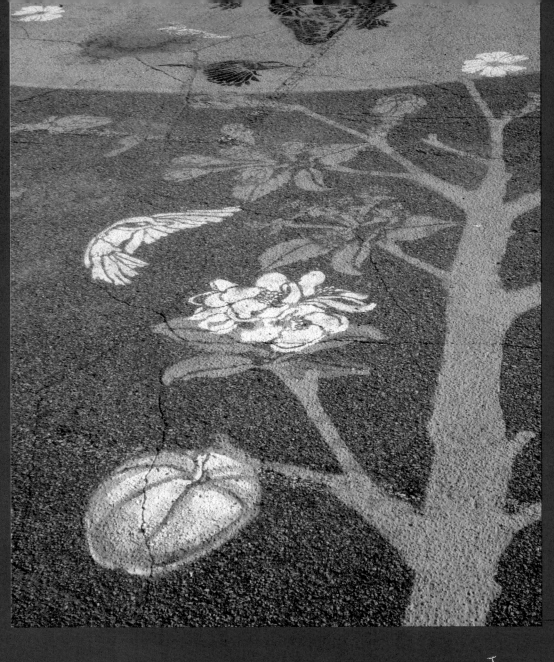

Olivier Blouin

ROADSWORTH
CROSSING THE LINE

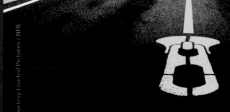

Courtesy Loaded Pictures / NFB

PRODUCED BY LOADED PICTURES IN CO-PRODUCTION WITH
THE NATIONAL FILM BOARD OF CANADA

Loaded
Pictures NFB
ONF

Sebastian Lange

Filmmaker Alan Kohl had begun filming Roadsworth before the arrest, thinking that his work might fit into a documentary about public-space interventions in Montreal. While Kohl figured that the arrest signalled the end of Roadsworth's career, and might adversely affect the film he was working on, when support started mounting and the city settled, he realized there might be a bigger story to tell. *Roadsworth: Crossing the Line* was developed into a full-length feature that covers Roadsworth's development from 2004 (pre-arrest) to 2008.

The attention garnered by the arrest, the support he

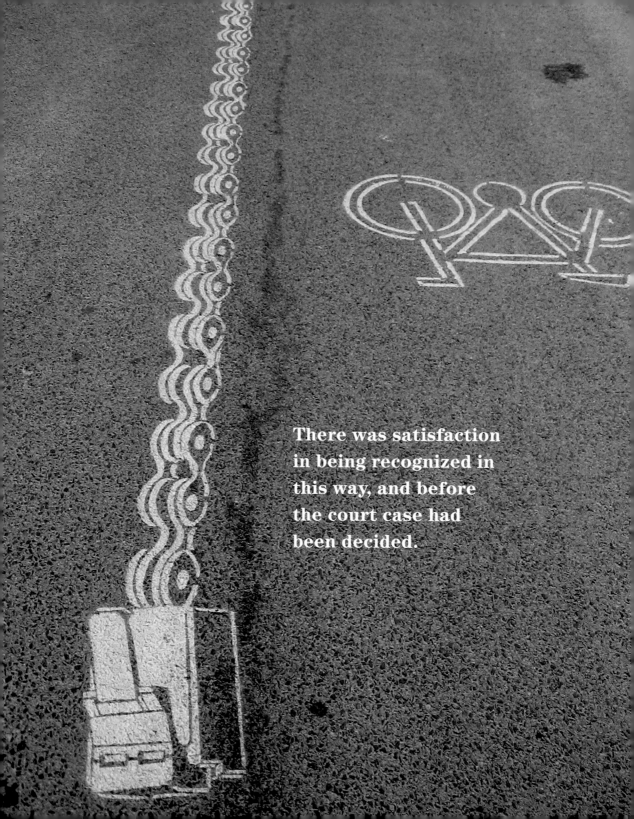

There was satisfaction
in being recognized in
this way, and before
the court case had
been decided.

LEGIT

Long before the resolution of the court case, Roadsworth received his first commission. In August 2005, as part of the Débraye exhibit at the Darling Foundry in Old Montreal, Roadsworth was granted a permit by the city to execute a bike path on the streets outside the gallery.

The fact that he was being granted a permit by the city suggested to Roadsworth there might be some leniency in the courts. It was further cheering to him to notice that specifically agreeing to a bike path on a road open to traffic handily undermined the city's own public-safety argument.

It was an opportunity to have a whole stretch of road and to do something I felt good about, without having to duck behind poles. It was an opportunity to do something artistically I couldn't have

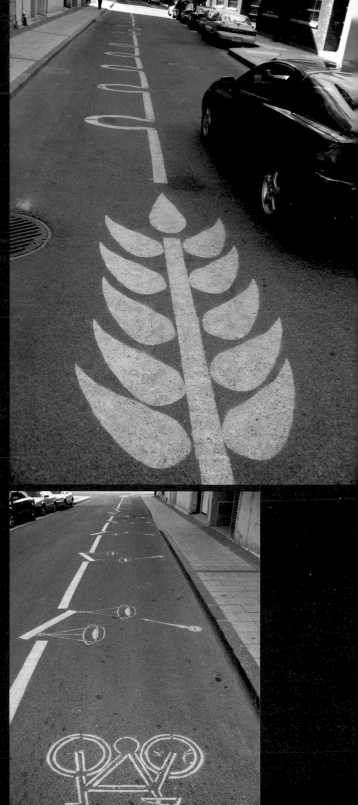

I decided I wanted to do a bike path. Also I wanted to showcase the history of the buildings the path went in front of by referencing what the buildings were, or had been.

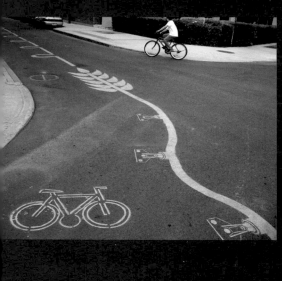

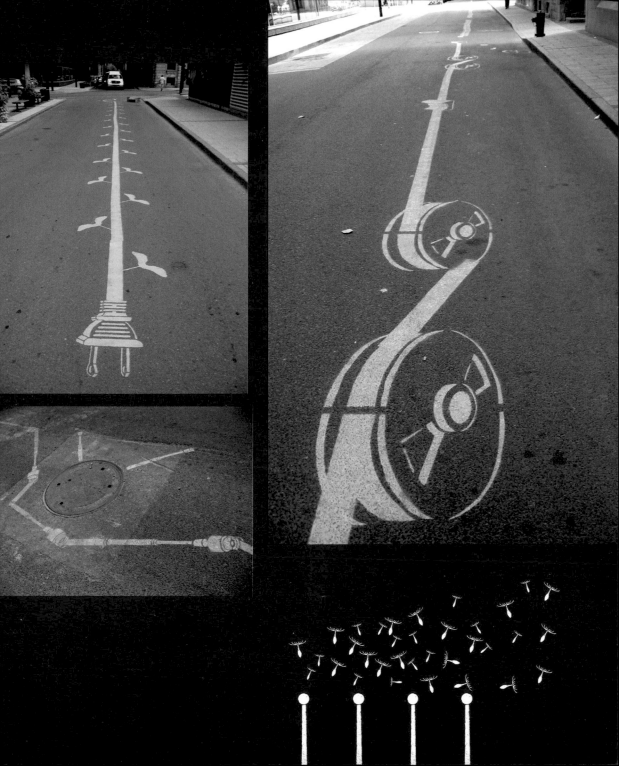

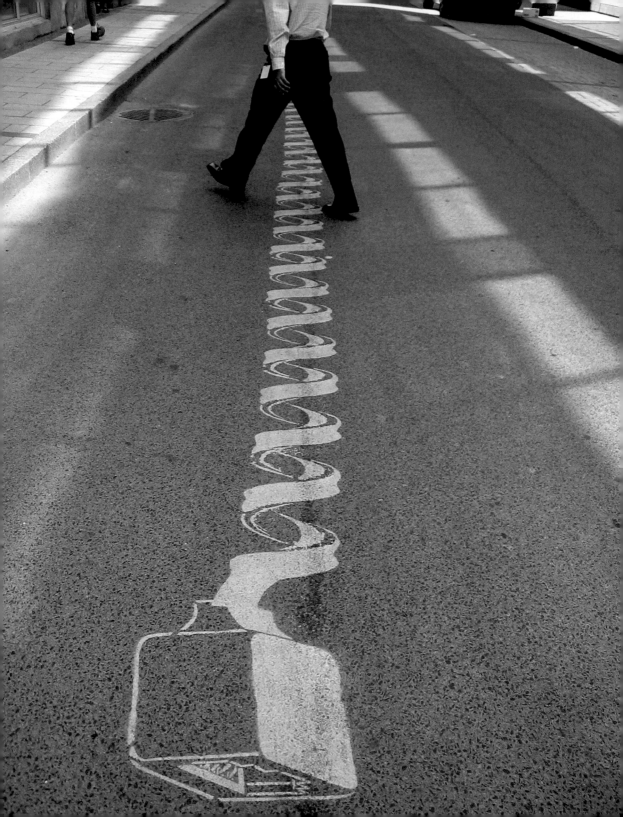

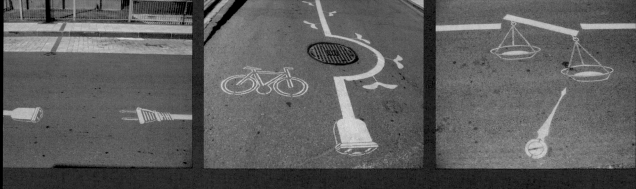

imagined being able to do on the street. Even though I was getting permission, I felt I was pushing boundaries. It was exciting. I had a couple of people helping me, and the filming of the documentary was in full swing.

The commission represented a step into a milieu where Roadsworth would no longer be anonymous — and in fact all conditions surrounding the creation of his work would start to change. He was suddenly allowed the time, space, materials, help and freedom from prosecution that would allow him to expand his work in all respects. He could start to create work on the scale he had been imagining. Concepts could evolve into more complicated executions, colour palette and materials could be experimented with, he could hire help for the more involved pieces and he could come into his own as an artist. He was about to hit his stride.

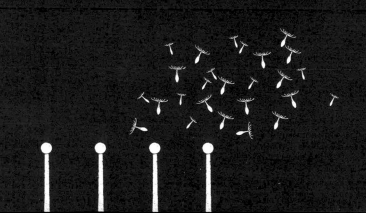

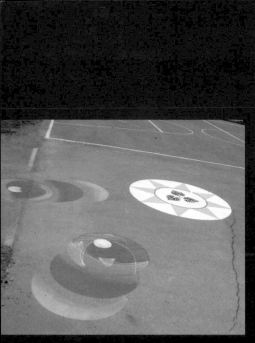

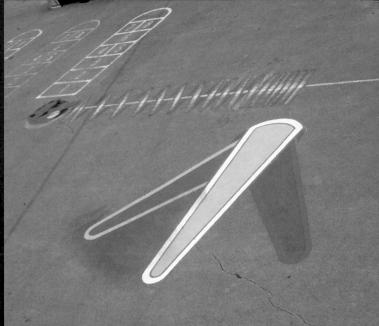

My idea at the school playground was partly that kids would come out at recess and run around like pinballs. I made up a game to go with it and everything. The principal was horrified at first, thinking that pinball suggested arcade culture, and therefore delinquency. I made the ball the earth, though it wasn't my original intention.

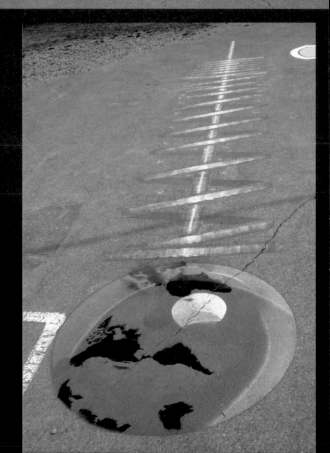

As Roadsworth's work evolved, and he was given time and space to consider more complex design, he adapted his methodology. Early on, when designing a large or complicated piece, Roadsworth would create a collage by hand, cutting, pasting, photocopying, until he had a plan he could work from. As his work developed in intricacy and size, this method became untenable, and he has started modelling with computer. He also went from using spray guns with latex paint to water-based paint and a roller.

With a commission, I start by checking out the area that's been chosen for the installation. I take pictures, sometimes measurements. I try to be sensitive to what the space means, or has meant. I do a lot of rough sketching and make notes. When I have a concept in mind, I search for imagery from photos or what I see. This generates more sketches, and from this comes a finished drawing. I photocopy or use a computer to manipulate images, elements in a piece, try things out, place them where I want them. Then I draw directly onto cardboard, or transfer the drawing onto acetate, which I project onto cardboard or Masonite. Some imagery needs to be sized in a certain way, especially when it's to be used in conjunction with other elements, but some can be done more directly without the use of an overhead projector. Once I've drawn on cardboard or Masonite, I sometimes refine the design further (in the case of shading, for instance) and then cut it out using an X-acto knife or rotary saw.

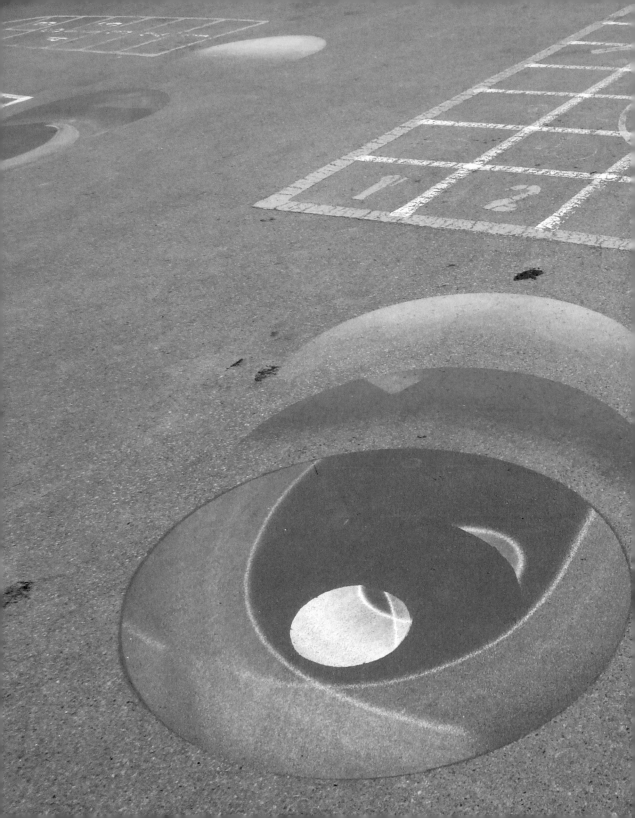

I often use stencils several times in the same piece — repetition of design within a piece is common. Different colours and layers can be applied depending on the complexity of the piece.

I often draw with chalk directly onto the surface and then use masking tape to mark off the areas I want to paint, creating a sort of stencil in situ. Other times I will simply draw something with chalk without masking it, depending on the situation and how clean I want it to look. Tape is most useful for straight lines and large pieces. I tend to use paint rollers a lot when doing a commission. I also discovered the use of a paint gun, which allows me to use regular latex house paint, for example, instead of relying on a spray can, which, while effective, is toxic and hard to clean up.

When I started getting commissions, I started to expand the palette. The fact that I've painted a lot of asphalt means I use a lot of yellow, white and light blue; but for me the concern most often is integrating the piece with its environment and whatever colours I think work best under those circumstances, rather than some kind of adhesion to a colour scheme. Having said that, I have developed a kind of personal colour theory based on the colours black, blue, grey, yellow and white.

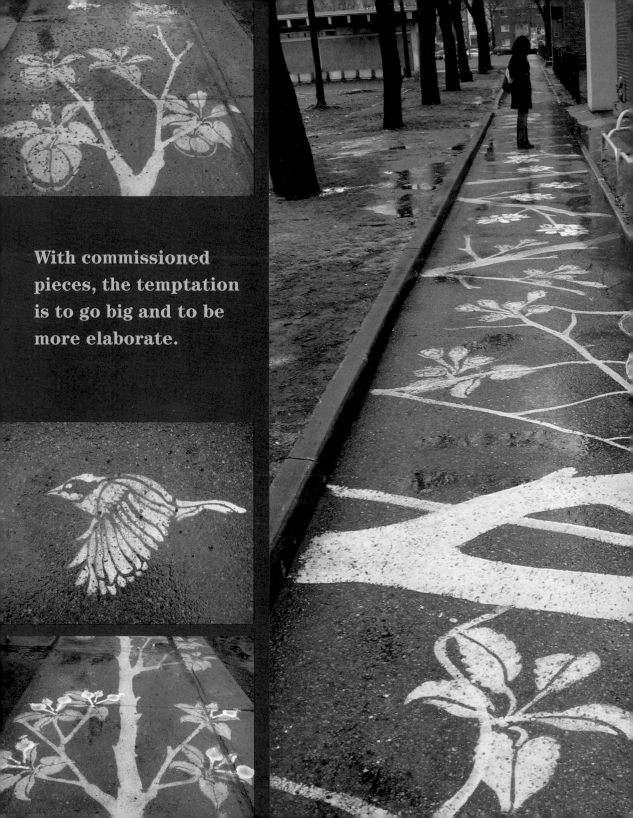

With commissioned pieces, the temptation is to go big and to be more elaborate.

With commissioned work, Roadsworth is offered spaces to paint that are, as a rule, "blanker" and larger than the spaces he would choose for himself. Often there is nothing obvious to use as a starting point for a piece. Rather than pulling a concept out of a pre-existing line on the road or sewer grate — which tends to compel him to go for a kind of subliminal, more minimalist approach — commissions mean expanded possibility, a different conceptual workup, and therefore greater challenges.

While Roadsworth's street art has informed his commissioned work in all respects, he has also been able to adapt some of the techniques and materials developed in commissioned work to the street.

Doing commissions allows me to try out methods and equipment which I can then bring back to the street. Things like using tape to mark where I want to paint, making a stencil on the spot, is something that I've translated to the street though, of course, it can be tricky because of scale and the time required. I tend to use paint rollers a lot when doing a commission and I've brought that to the street as well. And while the paint gun I often use in commissions is a large thing on wheels, using it led to the discovery of a more portable one that I can use on the street.

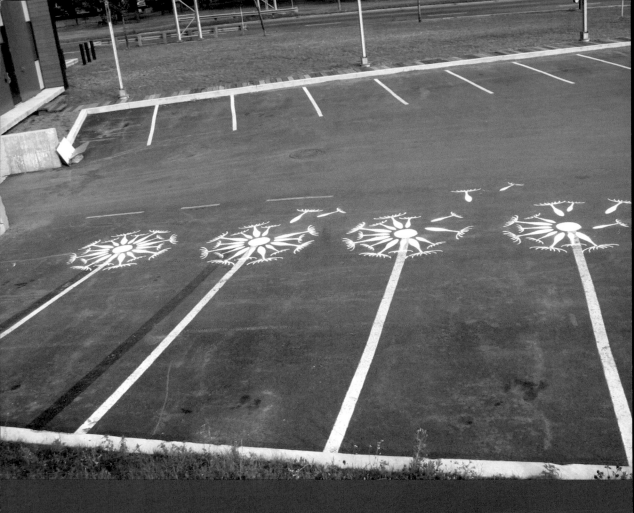

Having to create interest with the situations
I'm presented with, using whatever visual
cues are available, is what's challenging
and exciting about commissions.

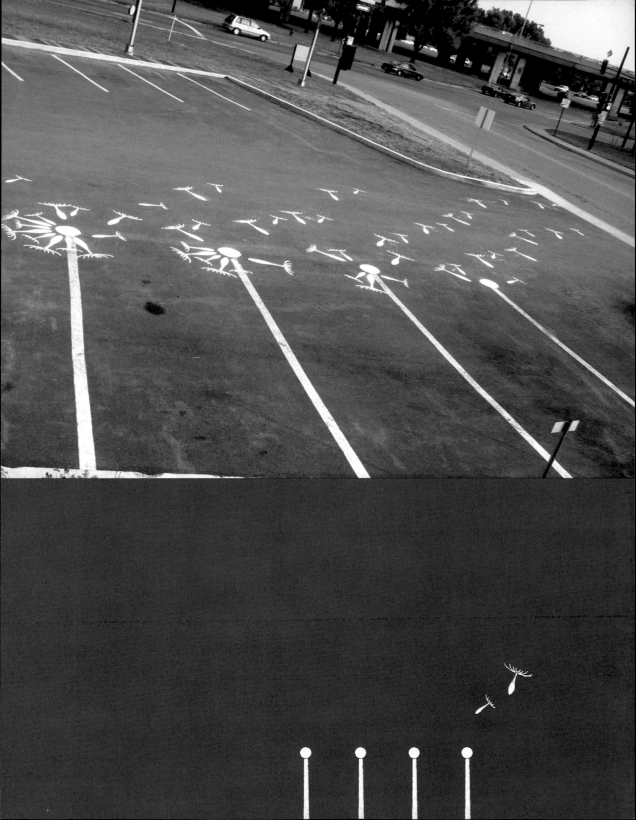

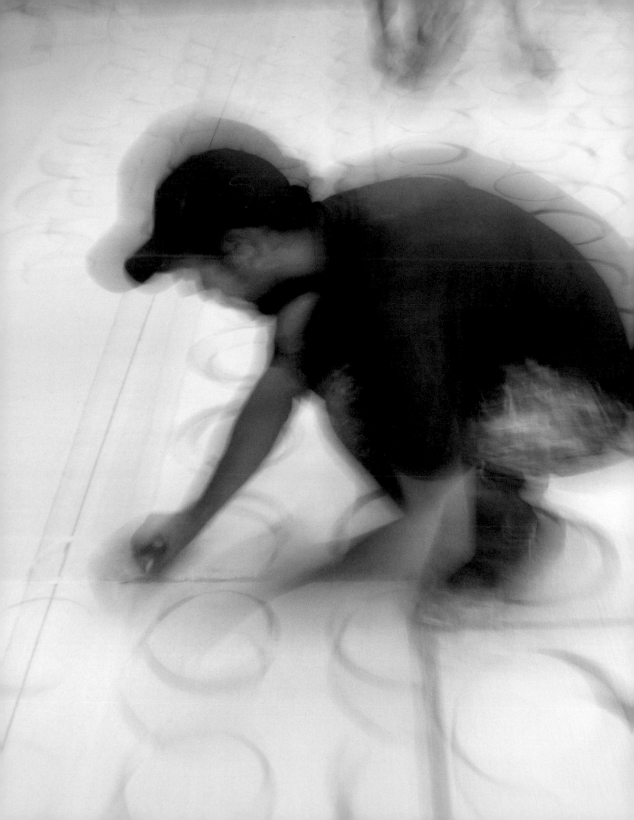

LEGOISME

In August 2006, Montreal's downtown borough commissioned a Roadsworth piece for the space in front of the entrance to the Place d'Armes métro and Palais des Congrès, which produced the headline **FROM VANDAL TO BUREAUCRAT** and prompted some in the media to question Roadsworth's "purity" as a law-breaking street artist. Roadsworth appreciates the irony of receiving a commission from the city, but sees it as logical that the city would endorse ideas of art which have been proven to resonate with people. Given the amount of public support Roadsworth received, it made political sense for Montreal to come around to supporting him too.

The Legoisme piece was partly inspired by the look of the building in front of which it was conceived. The building has greenish windows and a blockish, modular appearance that reminded me of Lego. It's always important to me that a piece looks as if it belongs in its environment, and I thought that Lego would bring out the toy-like aspect of the Palais des Congrès. Lego is like architecture for kids, and I wanted to highlight the "architecturality" of the space. I was thinking too of street art injecting playfulness into the world. The Palais des Congrès is such a serious, adult place and I wanted to

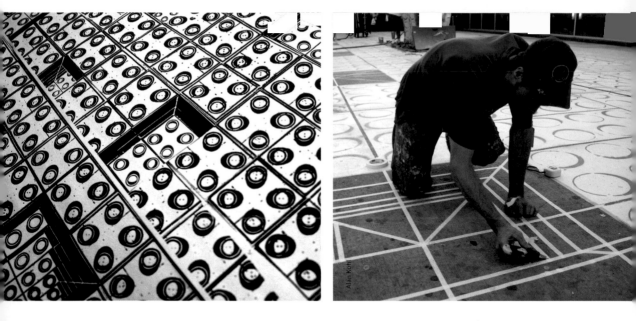

introduce something childish, as if to say that the building takes itself too seriously. But Lego is also synonymous with creativity—and it represents an early form of creativity for me.

This commission was probably more self-referential than most. It marked a bit of a milestone for me. I had just been through this whole media and legal thing and now I was being given this space, by the city no less, to make my mark. I was sort of saying, "This is my inner child, being creative, being playful in the city, and on a large scale." It was my "look at me y'all" moment. Hence the title.

Generally I haven't felt constrained in commissioned work, except by the space I'm offered to work in. And I'm probably influenced by the expectations of the client, though it's always been presented that I can do what I want. The challenges then are often as much implicit as they are explicit. Often there is the desire, although very subtle, almost subconscious and despite myself, to please or to at least not

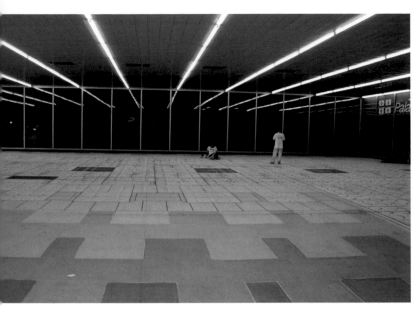

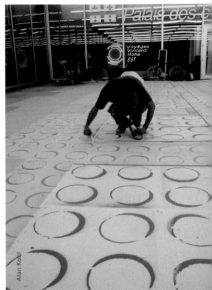

Alan Kobi

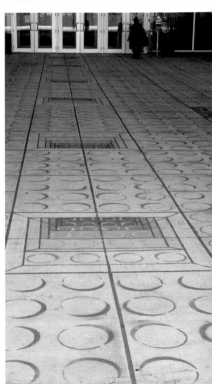

offend the client, though most of the
commissions I've done have been for
clients, causes, events whose mandates
I believe in, and so it does not feel like
I'm compromising my integrity or having
to distort my vision in any way. And rarely
if ever do I have to modify a concept or
design to please someone.

I always try to be a little sarcastic, sub-
versive. Some commissions want me
to be subversive; in some cases they
don't think I'm being subversive enough,
though to be subversive in the context
of a commission can feel contrived, and
there isn't always the need for it. I never
try to do damage to or hurt anyone.

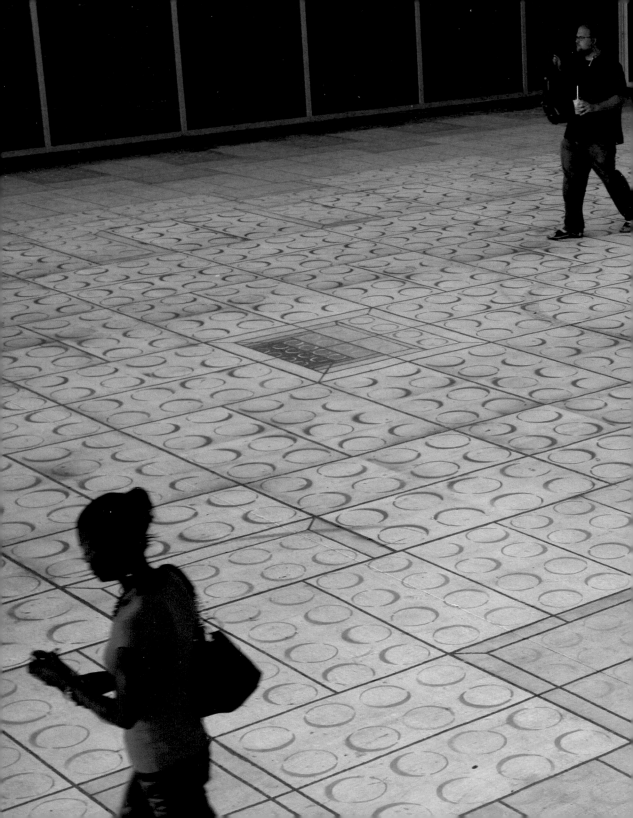

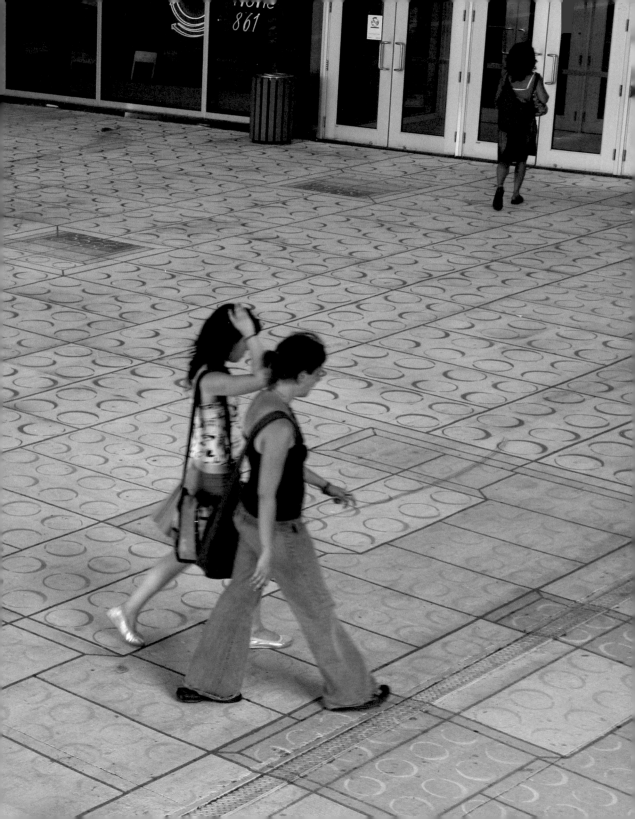

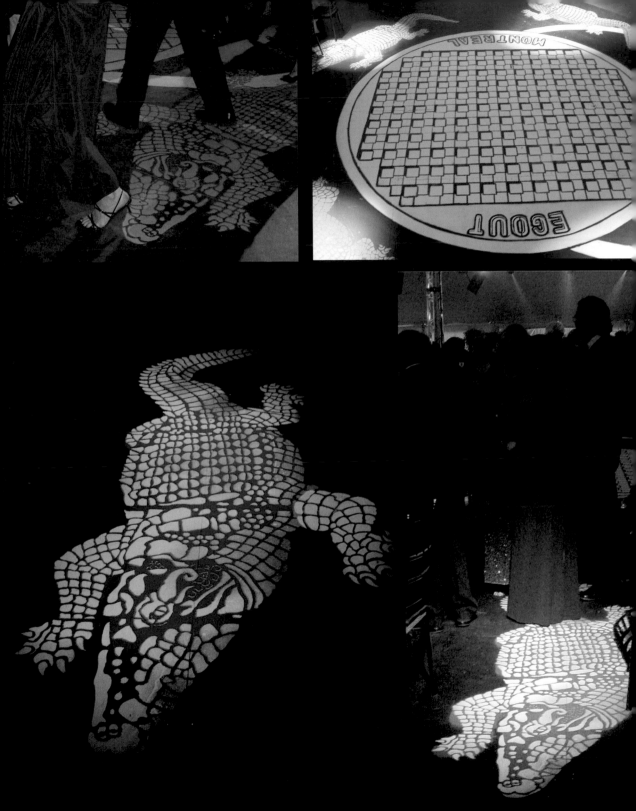

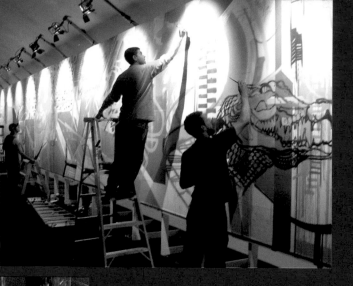

CCA FUNDRAISER

The Canadian Centre for Architecture fundraiser happened in conjunction with the opening of an exhibit for which several street/graffiti artists were invited to paint a massive canvas that would be auctioned off in pieces to the dinner guests. Besides the canvas, I was commissioned to paint the (dance) floor of the tent where the black-tie event was happening. I chose the idea of "urban legend"—specifically the one about crocodiles living in the sewer system. The dance floor itself was a massive Montreal sewer cover and the crocodiles were emerging from it. The whole thing was in keeping with the "urban" theme, and that was how I presented it. But for me there was another reading of it that was maybe a little more subversive. The idea that these crocodiles would emerge from a hole in the ground in the middle of a formal dinner suggests a disruption on an absurd scale, a disruption of decorum (the black-tie dinner being the epitome of decorum), a disruption of business as usual, a vulgar, almost violent (man-eating crocodiles) intrusion into the rarefied world of millionaires, businessmen and politicians. The event seemed like a sterilized version of all things "urban" (urban dancers,

urban art, a mini basketball court), so there was a certain amount of
sarcasm behind the piece, especially since the people who hired us
seemed oblivious to what street/urban art was about. I felt a degree
of discomfort with the vaguely exploitative feeling of it all, which
inspired me to be subversive, like the court jester.

**The undermining of attitudes, of expectations,
is a positive force, even if it's critical.**

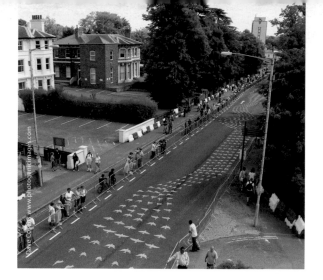

THE LOST O

In July 2007, Roadsworth travelled to the town of Ashford, England, to take part in the "Lost O" exhibition. The Lost O featured performances, installations and interventions by international artists. The event was conceived to mark the reinvention of the town as it prepared to reconfigure its ring road (which cut the centre of town off from everything that surrounded it), and in so doing to transform it into the largest shared-space scheme in Europe. The Lost O coincided with the passage of the Tour de France through the town.

Roadsworth's piece was directly related to the idea of the peloton, the bike pack, that phenomenon not just in pro cycling but also in human motion and transportation in general, and how it is reflected by nature.

There were a lot of logistical issues with this one. The studio that was made available to me for preparation was miles outside of town and it would take an hour and a half to commute there. The studio itself was a pleasant space in a pretty seaside town, but it concerned me initially for logistical reasons.

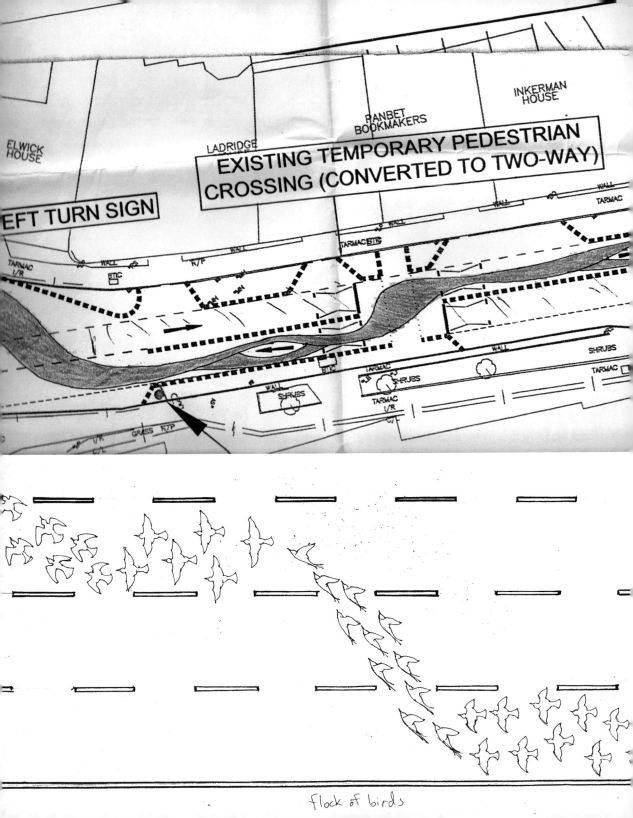

flock of birds

Roadsworth

oposal for Lost O projekt : Universal Synchronicity

Inspired by the concept of the "peloton"
here cyclists form a "pack" utilising such
oncepts as "drafting" to conserve energy.
he idea is to portray a "nature's peloton" so to
eak, manifested by schools of fish for example
flocks of birds that move synchronously,
ontinuously alternating between vulnerable and
ore secure positions within the school or
ock as a means of confusing predators. This
rm of cooperation is not only reminiscent of how
y clists manoeuvre within a pack but also
w human traffic operates as a whole. Depending on
w much road is available, the idea could be ex-
nded indefinitely with schools of fish morphing
to a flock of birds into a pack of wolves for e.g. into
ing maple keys, into a pack of cyclists, a formation of jets etc.

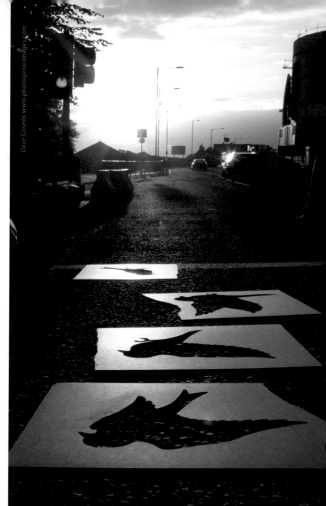

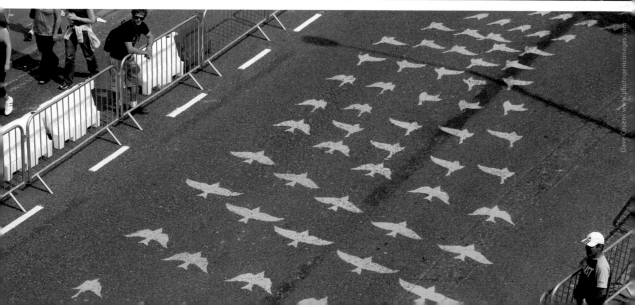

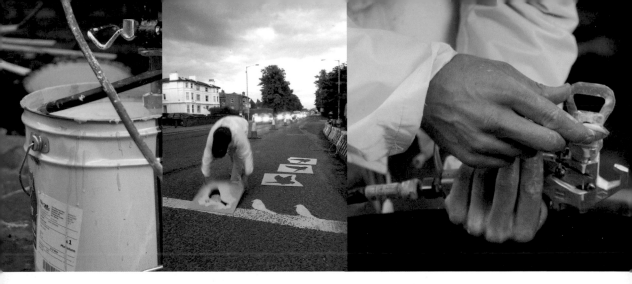

Then I was told that traffic was supposed to continue to flow —
with a minimum of interruption — during the execution of the piece.
The volume and speed of traffic along that road at times was such
that tour buses and eighteen-wheelers would practically brush our
shoulders as we hunched over, working on a section of the road.
Protection was a lot of pylons, some high-viz vests, traffic signs and
the co-operation of a couple of road workers.

The piece had to be completed according to a strict schedule: they
were waiting for me to finish so that construction on the part of
road I was working on (patching and barriers) could start and
finish before the Tour de France rolled through town. This made
for a slim margin of error, which was made slimmer by the typically
uncooperative British weather and the fact that there were many
technical difficulties to contend with. I spent the better part of two
days chasing down the right kind of paint, which eventually had
to be ordered from another district altogether. Then when the rain
abated and we were finally ready to get started, we realized we had
the wrong nozzle on the spray gun and had to spend another day and
a half tracking down the company that makes that particular gun,

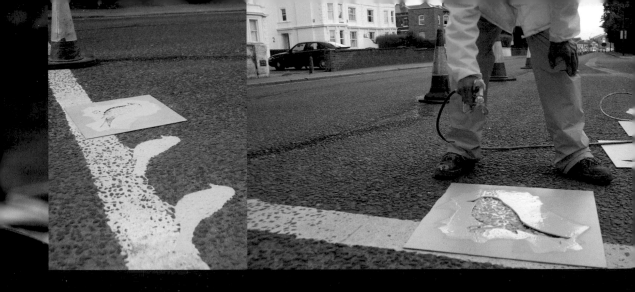

The Tour de France/Lost O piece was a study in the logistical challenges of working on a large scale, on an outdoor/public installation.

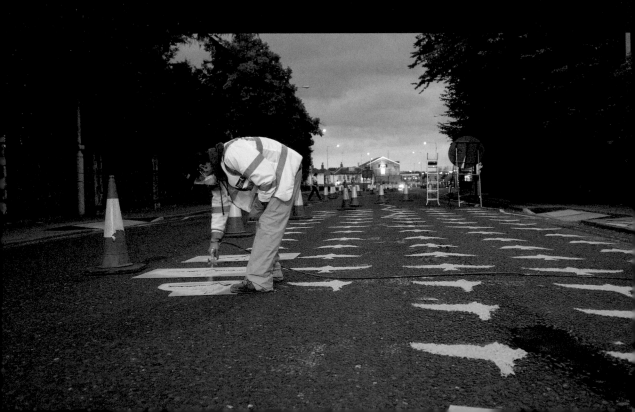

driving many miles to get to it. In the end, after a week and a half of tracking down materials, and drawing and cutting stencils, I worked almost twenty-four hours straight, with the help of an assistant, to execute the piece.

This "down to the wire" timing is typical of a lot of pieces I've done. Hectic, but memorable. I complain about the stress of scrambling at the last minute and vow never to put myself in the same position, but then seem to find myself there again and again. People who observe this suggest that maybe I work well under pressure and put myself into these situations intentionally, or subconsciously. Hard to deny that there's a grain of truth there. There is a rush associated with this kind of modus operandi that I think I thrive on.

In some ways the commissioned work is instilled with as much adventure as the street art that I've done. While the work is more premeditated, and perhaps less spontaneous, than street art, there's a similar kind of rush, a sense that I might not make it, that it might not come off. Meeting deadlines, coming up with creative solutions on the fly, working with other people, working in other countries, all-nighters, unexpected circumstances, variability, weather, physical effort—all contribute to a general sense of adventure. There's an energy that can be exciting and creatively inspiring.

The experimental nature of the creative process means there are some things you just can't plan or account for. Especially outdoors and in a public context, there are always variables that are beyond my control.

photos: Dave Cosens www.photogenicimages.com

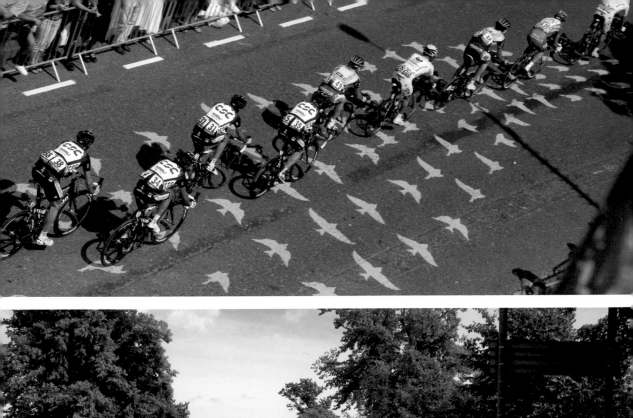
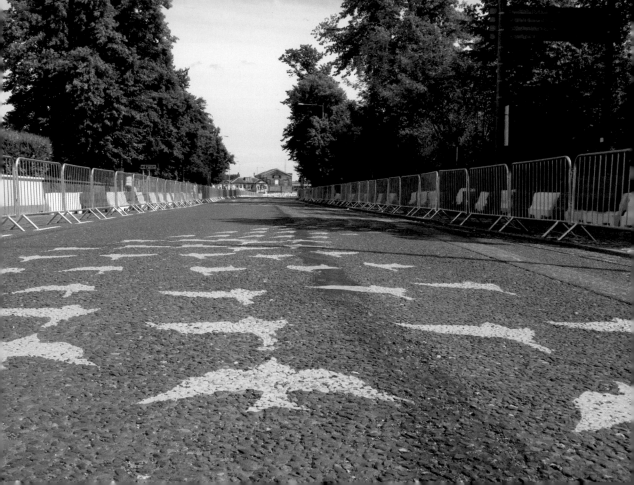

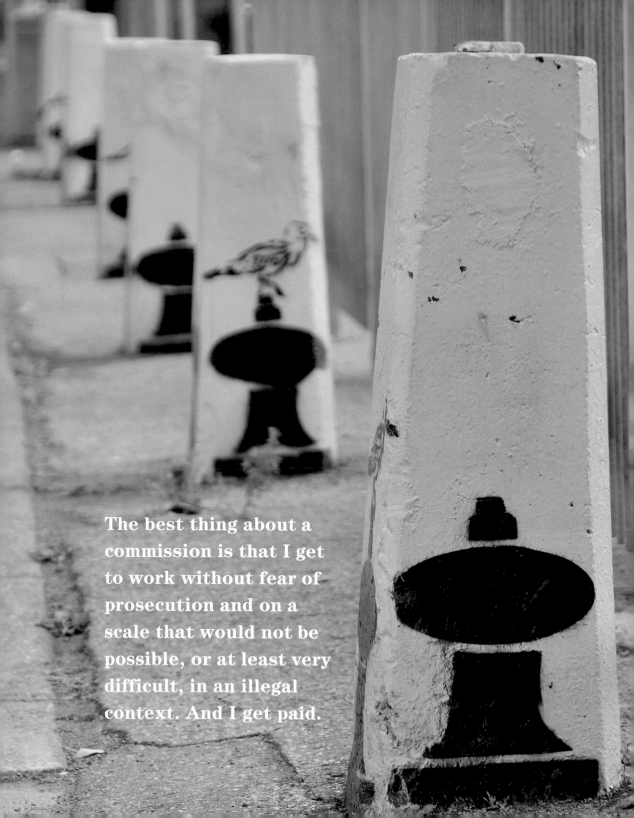

The best thing about a commission is that I get to work without fear of prosecution and on a scale that would not be possible, or at least very difficult, in an illegal context. And I get paid.

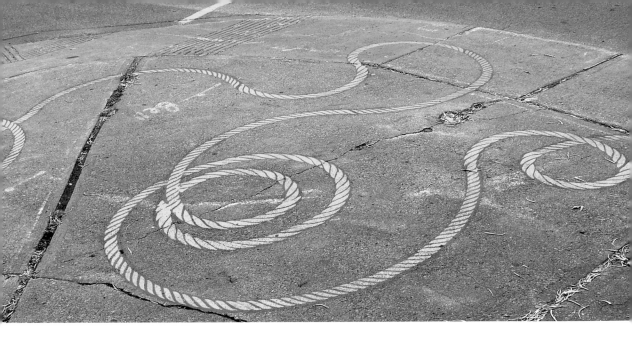

Despite Roadsworth's freedom to get to know an area before executing a piece, a great deal of planning still occurs on the spot, improvisation is often necessary, and things don't always go as planned. Time is always of the essence.

Going legit has pushed Roadsworth to exercise a new set of creative muscles, to think bigger in all respects. While the streets still call to him, the work he does in daylight, permit in hand, has opened new avenues he would not have anticipated having access to.

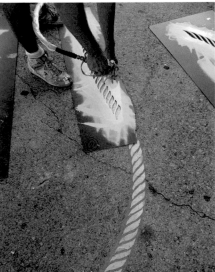
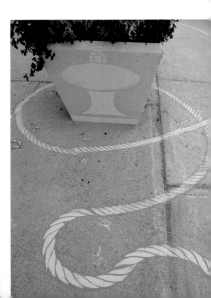

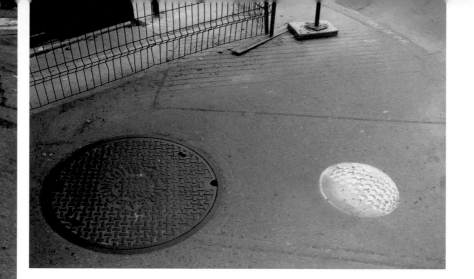

PLAY

One of the things that attracted Roadsworth to the art of Andy Goldsworthy was the sense of play implicit in its creation. Roadsworth grew up in downtown Toronto, and spent a large part of his childhood jumping fences, trespassing through backyards, exploring alleys, in ravines, climbing. He wanted to reconnect to that spirit, to get back to a kind of exploration people are encouraged to suppress as they age. Being a responsible adult is reinforced by the very set-up of the city, whose every inch is managed or owned.

The kids in our neighbourhood were allowed to explore.

You become an adult and you lose your sense of play. And why shouldn't you play, why shouldn't you explore? The way a city is structured discourages that exploration — either intentionally or as a result of people's fear, an imperative to feel secure — which saps fun. You don't really think about the potential for play in a city because the places designated for adults to have fun are highly controlled, and don't allow for much spontaneity.

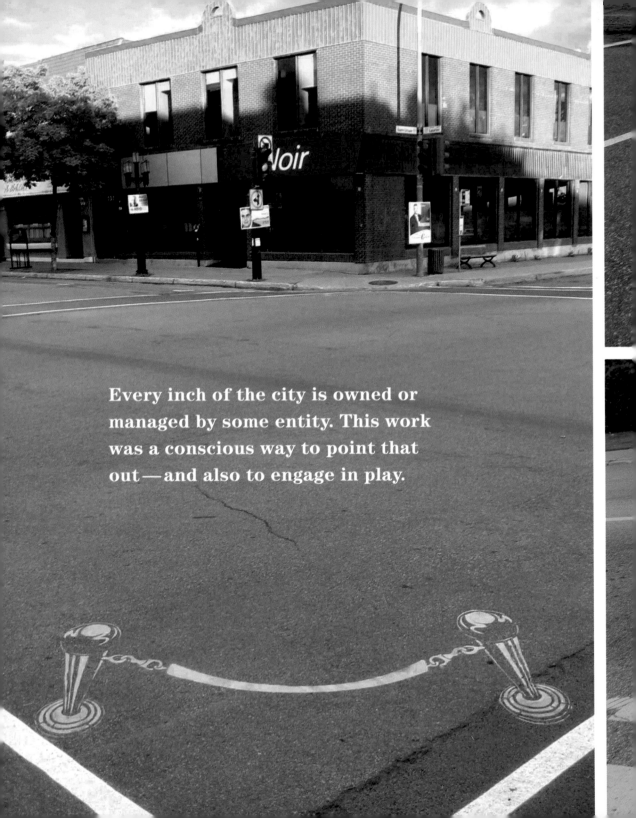

Every inch of the city is owned or managed by some entity. This work was a conscious way to point that out—and also to engage in play.

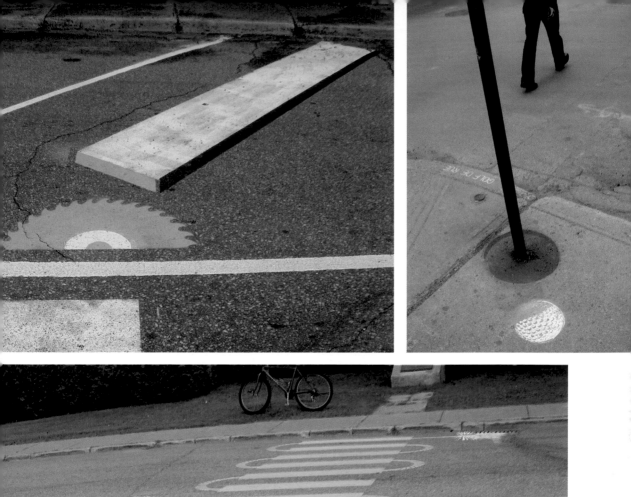
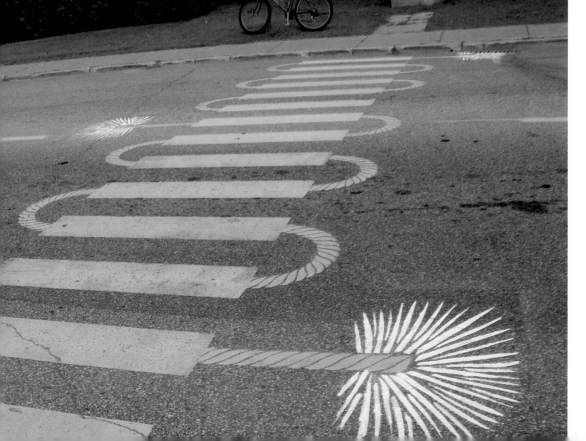

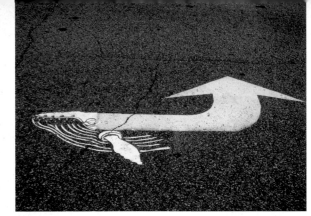

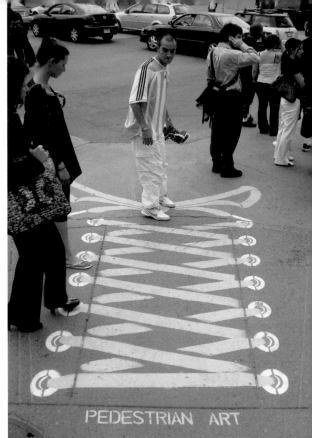

PEDESTRIAN ART

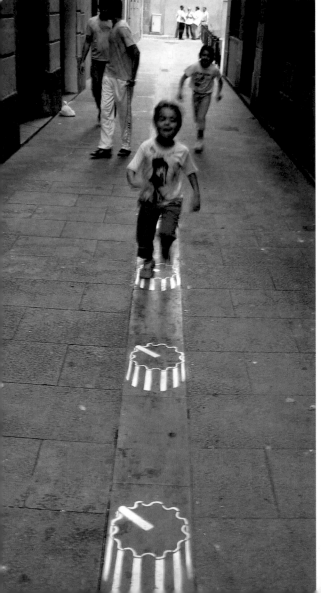

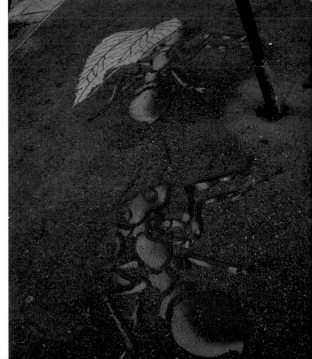

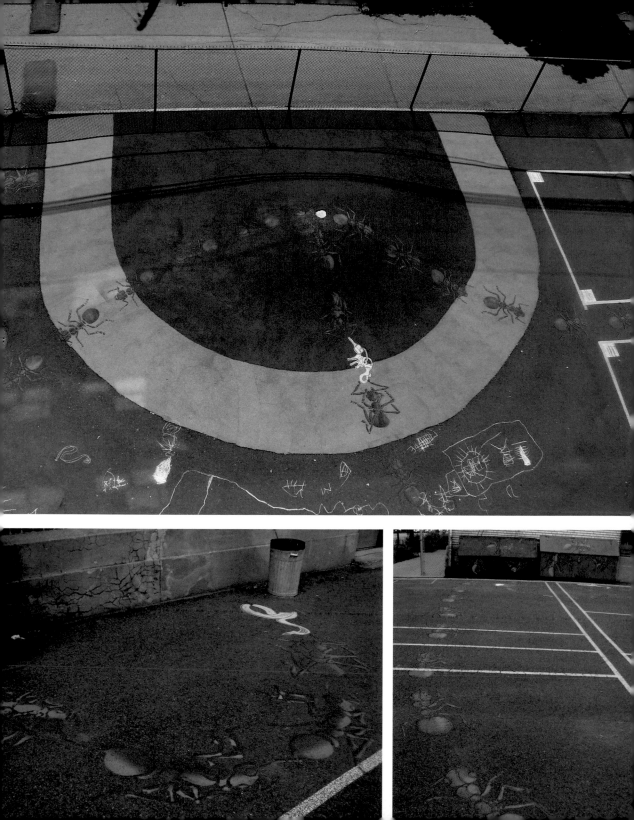

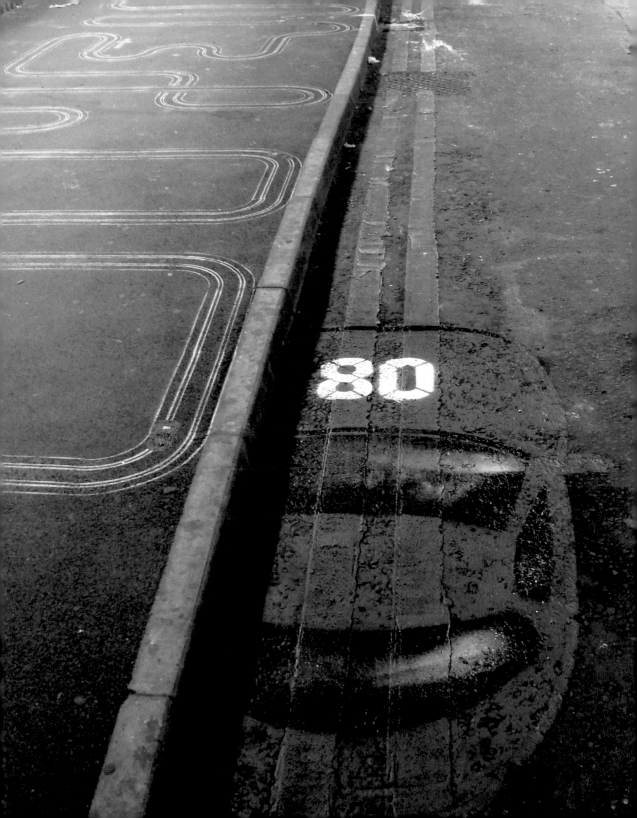

ANIMATION

More and more I am trying to create a visual happening or event: this is what's happening now, but something came before it and something will come after it. It also creates a sense of anticipation that I like. The pieces I create are static, but they speak of a past, present and future.

Some Roadsworth pieces require that the viewer move across them in order to appreciate what's happening, and to provide the animation. A viewer on foot or on a bike can make the piece move — flip the frames of the piece — with his or her own motion.

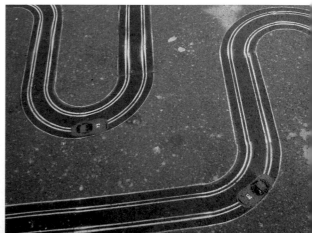

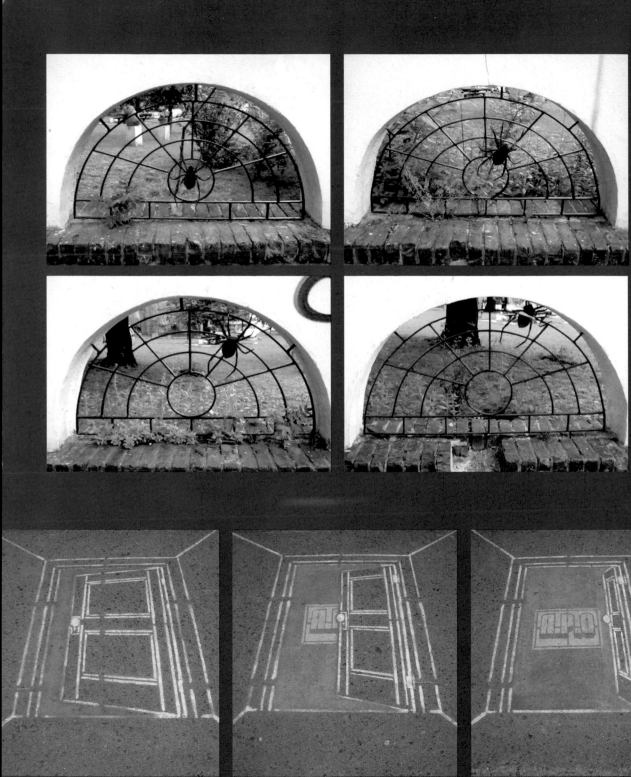

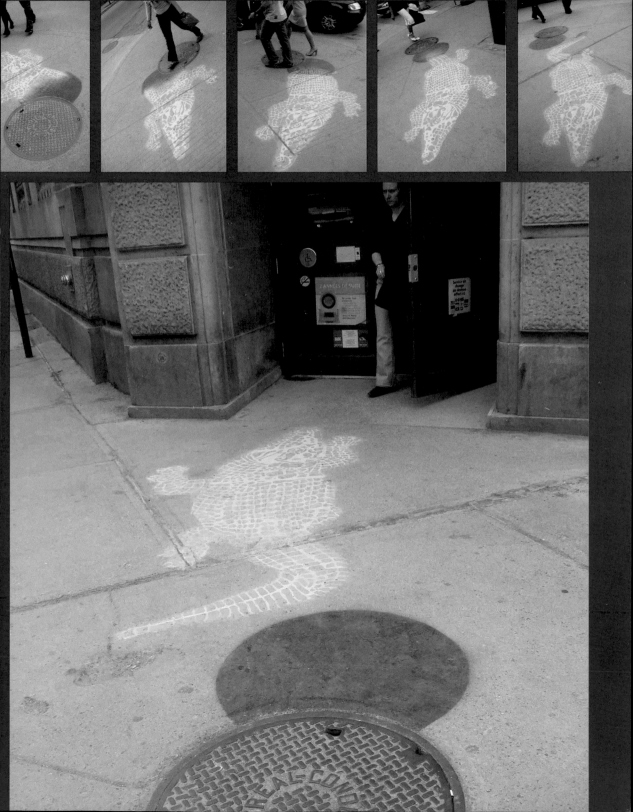

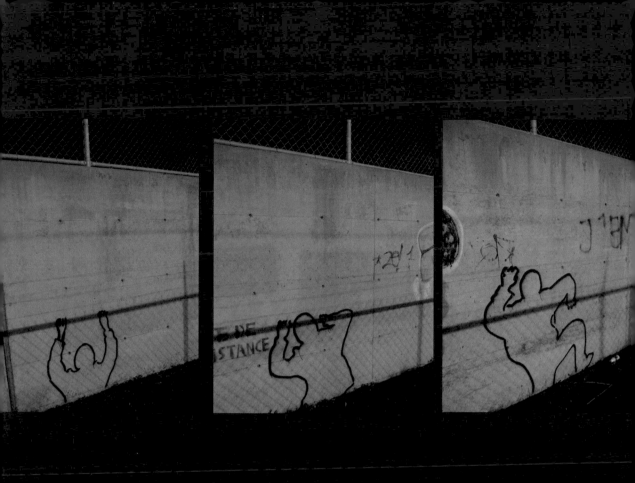

More and more I am trying to create
a sense of movement and story, of
narrative.

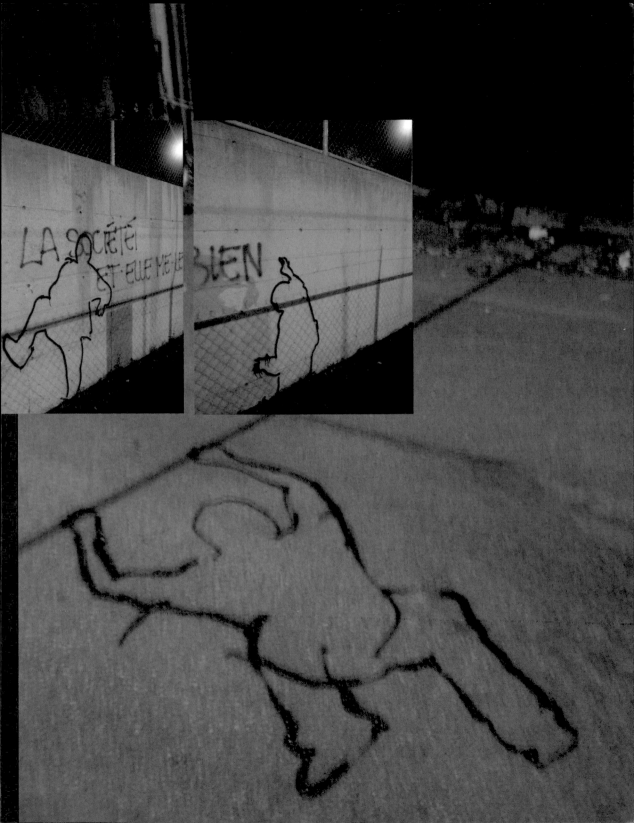

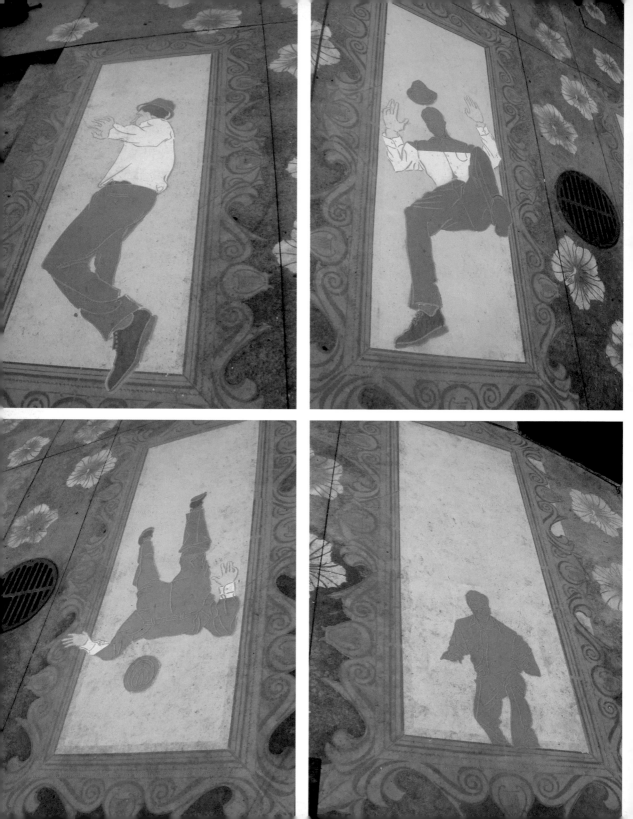

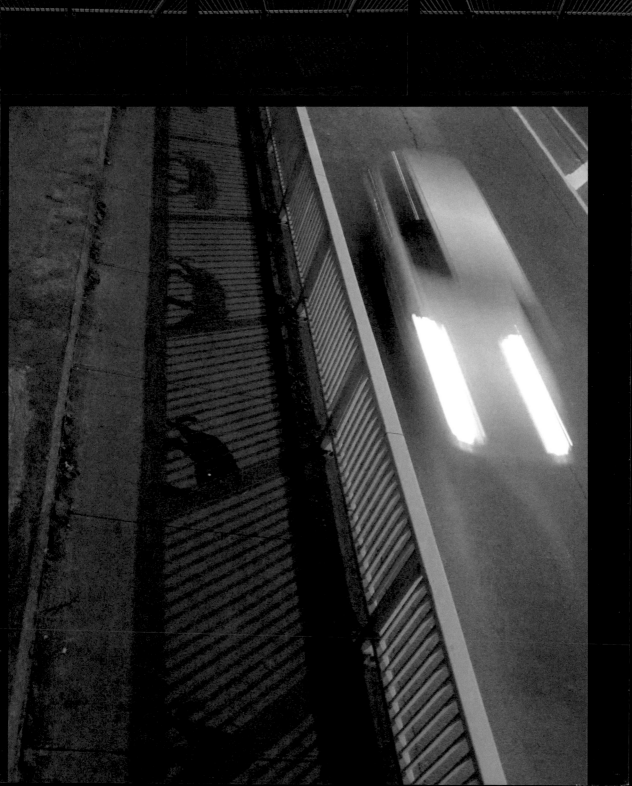

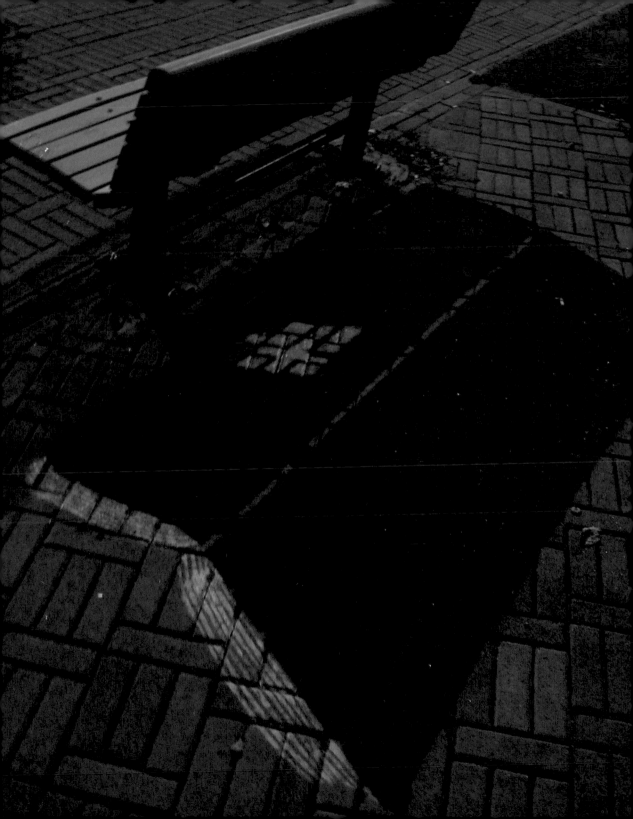

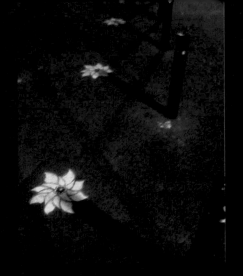

SHADOWS

With pieces dependent on shadows, produced at the right time and place, the goal is to create that moment of clarity.

One night I was out perching owls on street lines when I noticed that a telephone pole's shadow made a line across the sidewalk. I thought, well, why not perch an owl here? It became just another "surface" to work with, but one that possessed an ephemeral, time- or light-dependent quality that seemed interesting. People have told me that they notice most of my stencils are integrated in some way with the street, and they couldn't understand these apparently randomly placed, unrelated stencils. Like it seemed sloppy or inconsistent. Until, of course, they happened on them at night and the mystery was solved. That was the idea. To create a kind of dialogue with people, to evoke a certain amount of wonderment, to play with the temporality of the light, and of artificial light. And creating that moment of understanding, or revelation, is a way to bring viewers into the artistic process itself—which is full of moments of revelation.

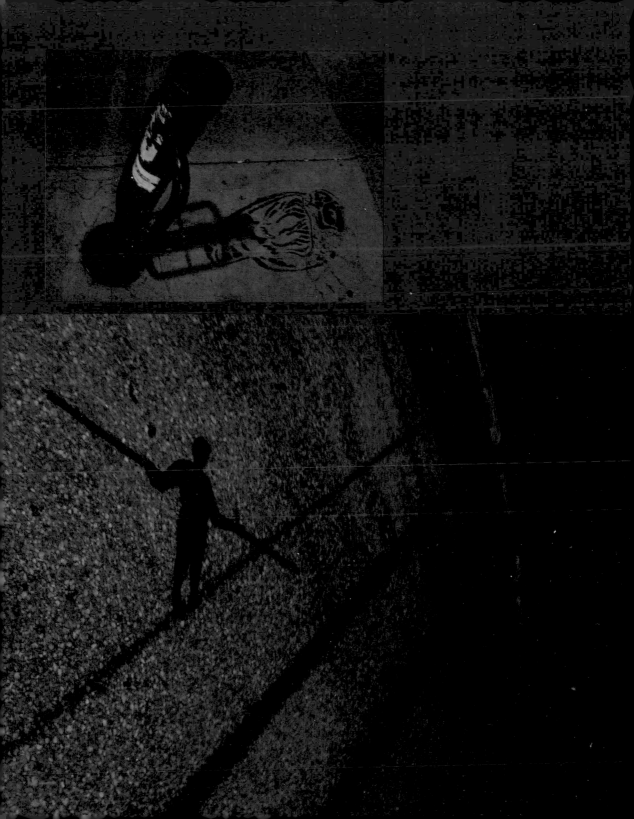

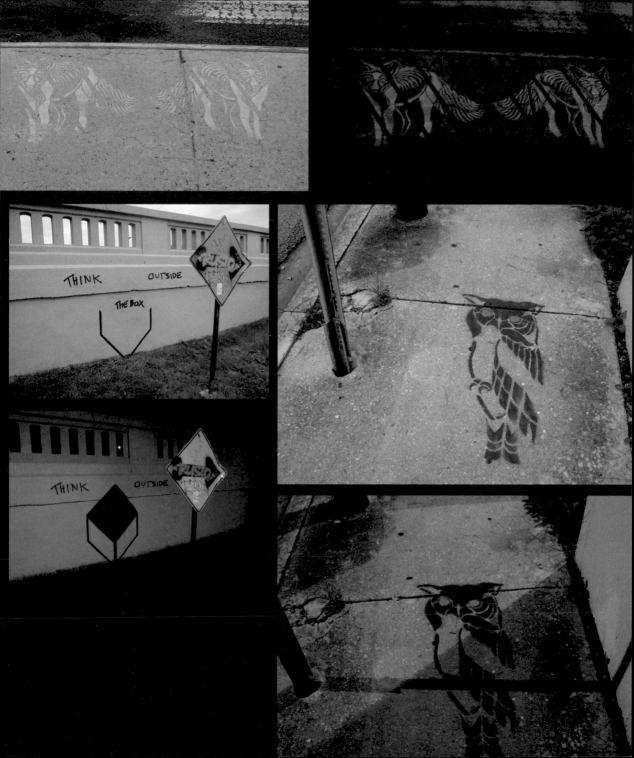

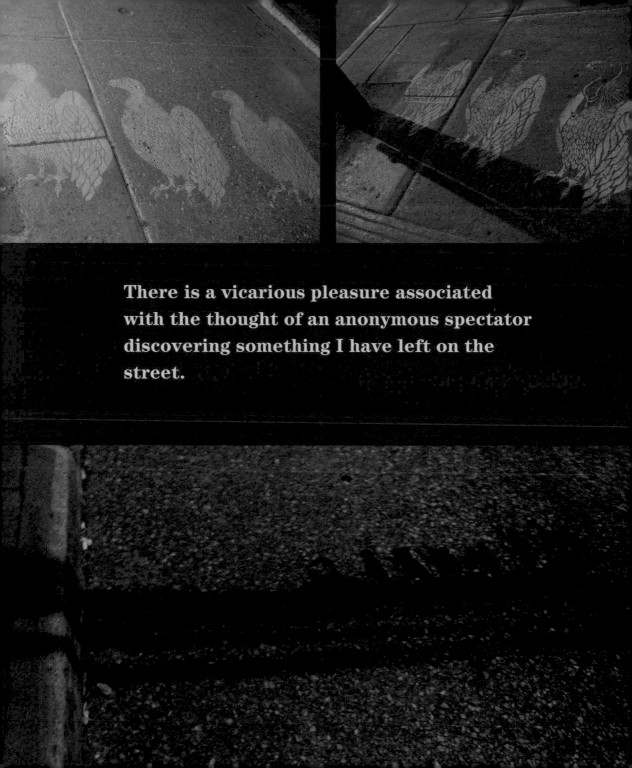

There is a vicarious pleasure associated with the thought of an anonymous spectator discovering something I have left on the street.

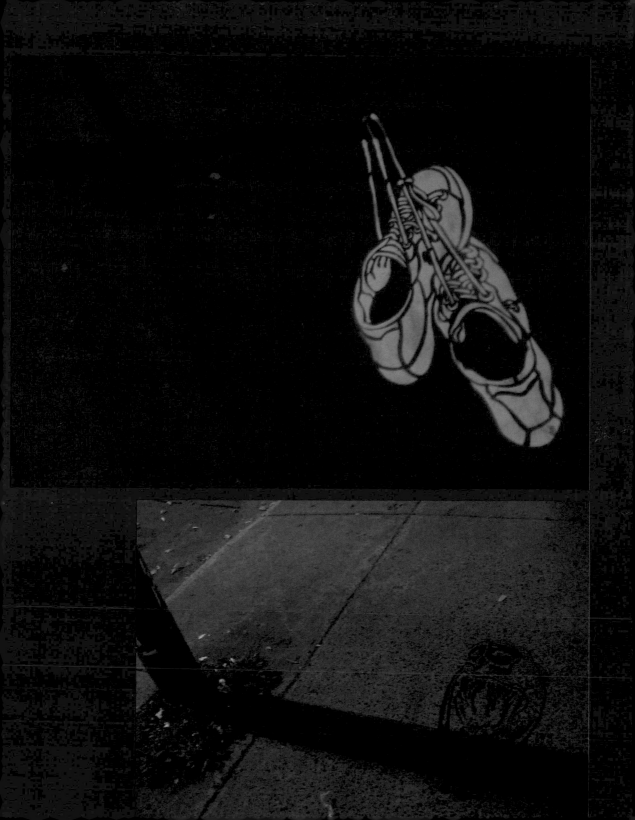

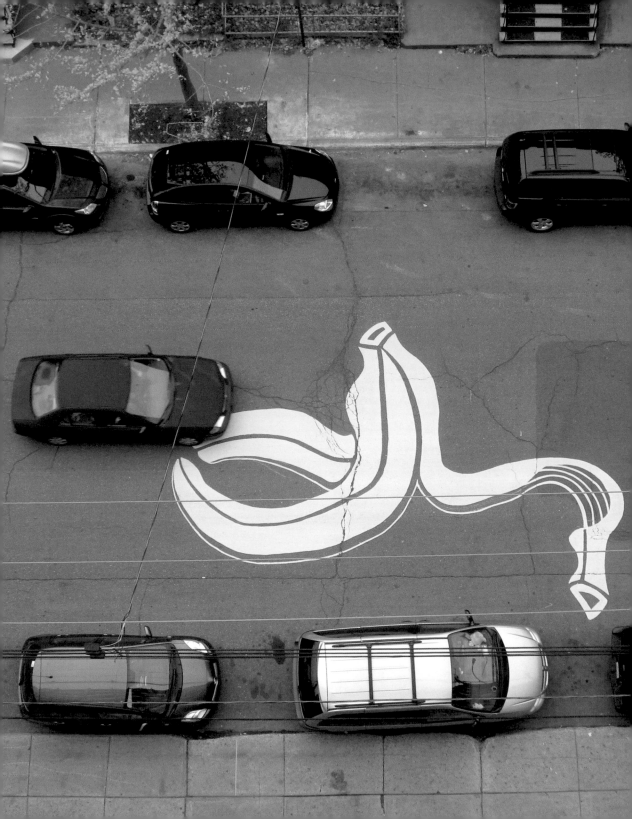

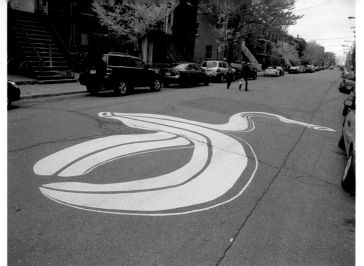

SCALE

I have a tendency to create pieces on such a scale that they are best seen from a rooftop or upper window. And often that window or rooftop doesn't exist or is not easily accessible. I will go out of my way to get to a height where I can capture it.

Before doing a piece, I'll often look out for those vantage points, being the collector of photos that I am. But I also like the idea of experiencing the piece at ground level, where you have to move across it — on bike, on foot, by car — to appreciate it; I like that you have to physically participate in the reading of the piece. Because the scale is often superhuman, the pieces engender a feeling of smallness, which appeals to me. I like the idea that until you use your imagination to try to see the big picture (or find a window or rooftop), the sense is one of slight confusion, of smallness, of being too close to really see what you are in the middle of. The view from the window or rooftop is like the "key" to the piece and requires an extra effort to attain it. Most of the time I'm the only one who makes that effort — and captures it in a photo.

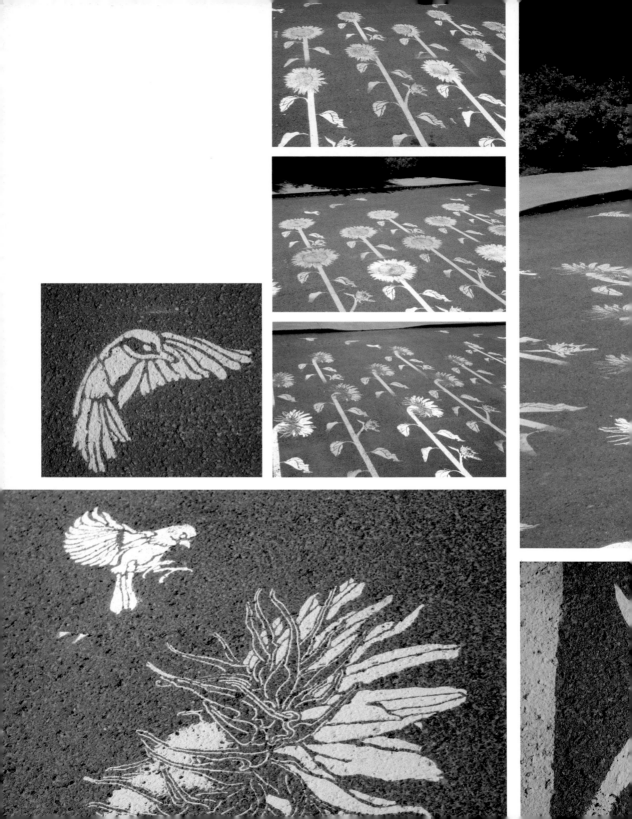

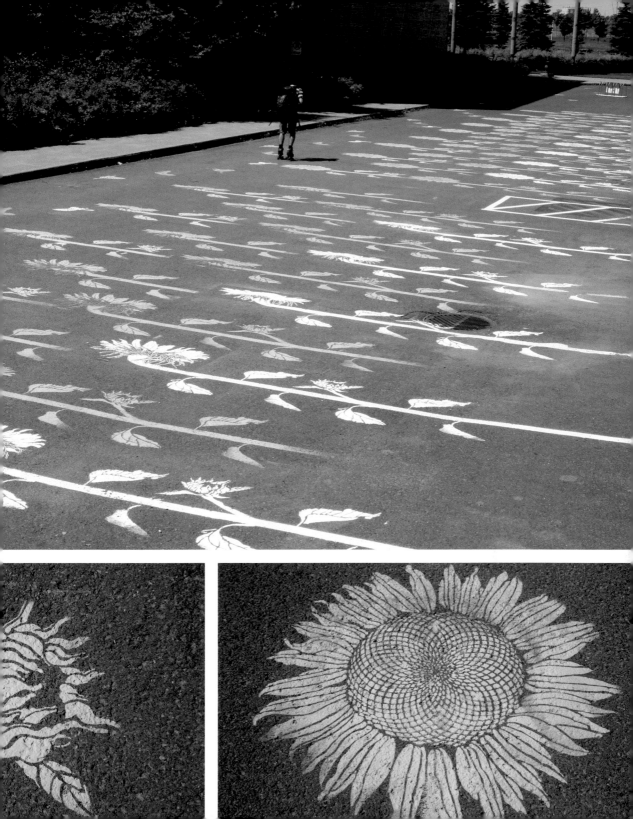

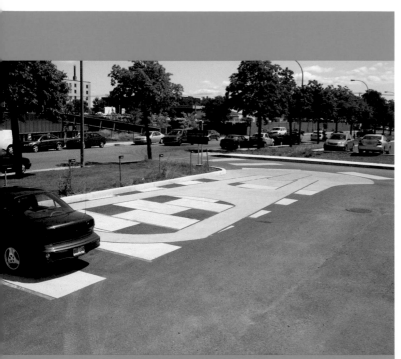

This issue of scale can create a "lack of perspective," and forces you to step outside yourself, to imagine you are hovering above the piece like an out-of-body experience, in order to see the big picture.

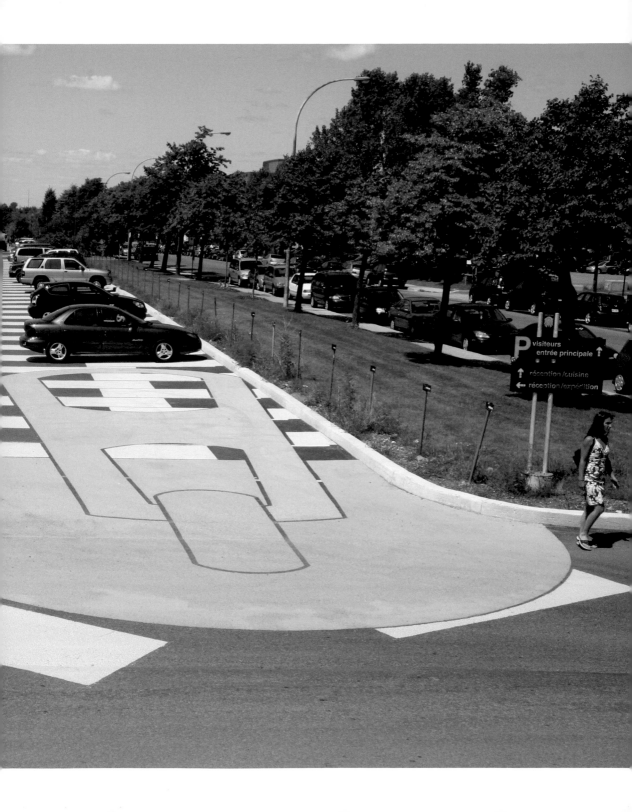

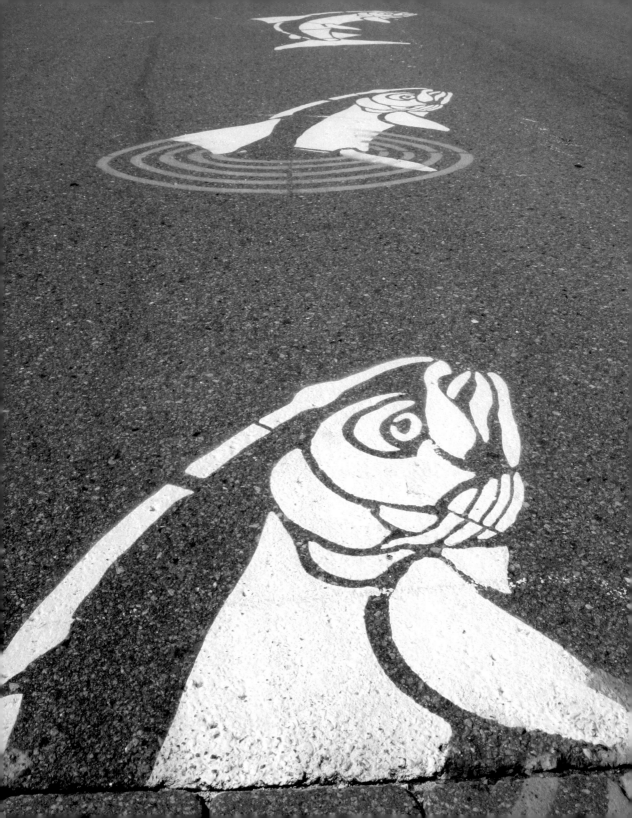

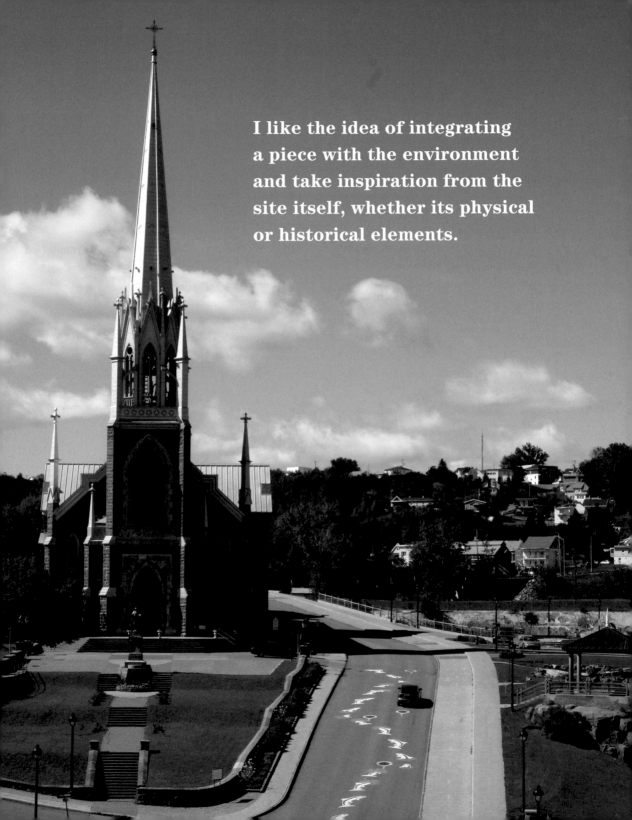

I like the idea of integrating a piece with the environment and take inspiration from the site itself, whether its physical or historical elements.

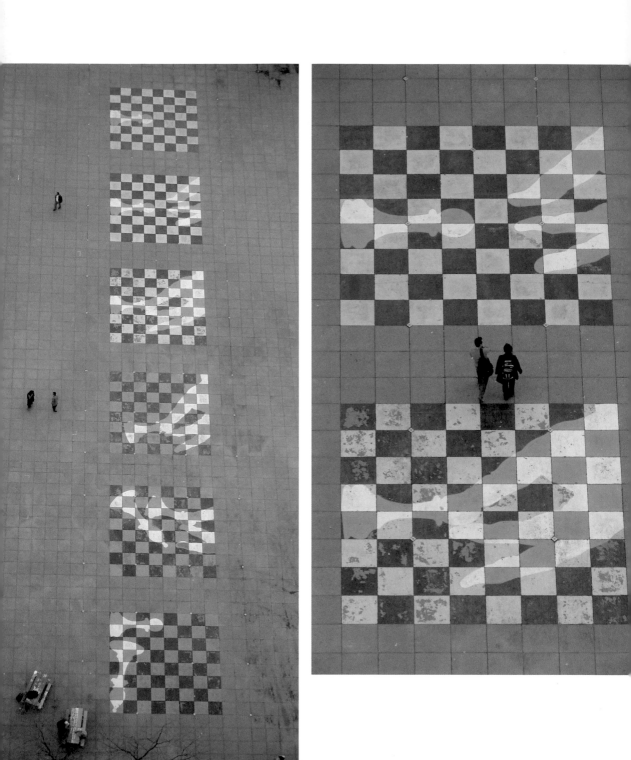

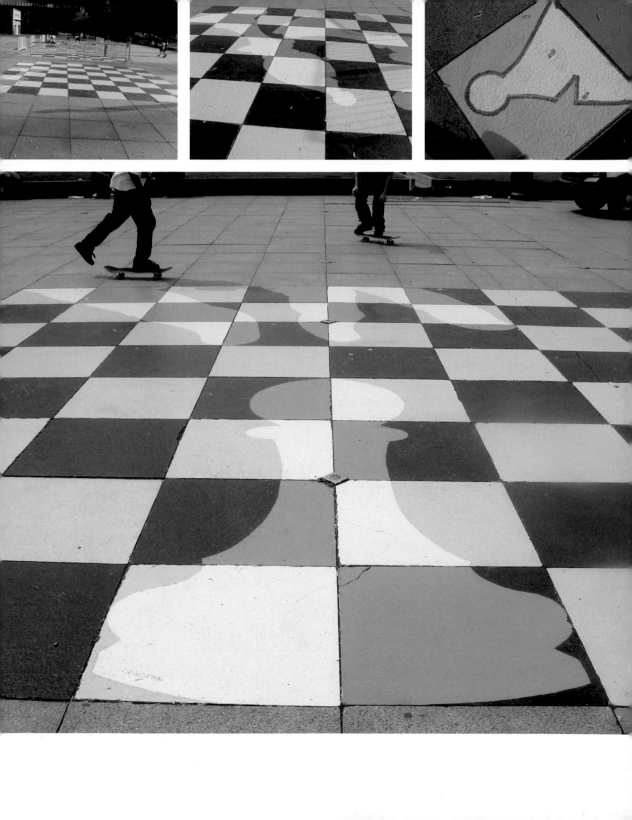

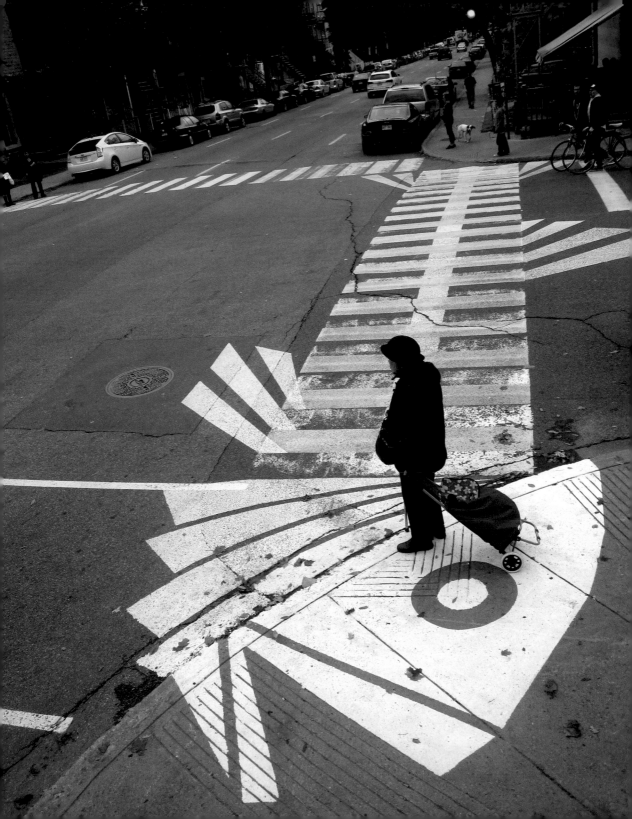

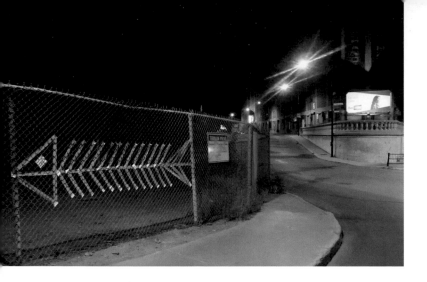

MESSAGE

A Roadsworth piece is often a wink, an inside joke (for everyone to get), a turning on its head of an idea we realize we take for granted only once we see it turned, a satirical twist, a funny, absurdist take on something our society holds dear or does not question; a view of the state of our world and natural environment that unsettles and pushes, and makes us question our commitment to this environment, and to each other. It also makes us laugh.

I'm not always sure what I mean when I do something. Sometimes I'm just playing, or trying to surprise. I want people to take the work in whatever way they do. That's the beauty of art.

My work is not always political, and when it is, it's political to varying degrees. The context of what I do can be more political and meaningful than the subject matter itself. A sunflower is just a sunflower, but a sunflower in the middle of a road or parking lot says something different than a sunflower on a canvas hanging in an art gallery. The fact that I use the road as canvas for a lot of my pieces, and where I place them within that context, accounts for

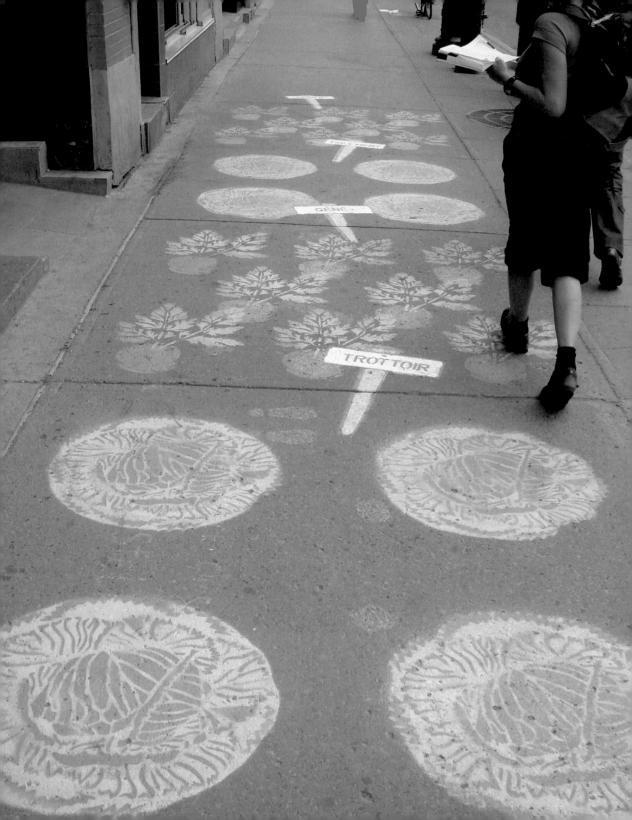

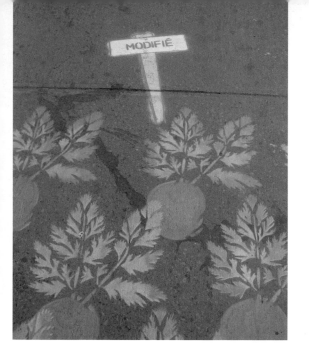

much of their impact rather than the images themselves. Part of the effect of my work I attribute to our subconscious notions of and relationship to the road. Intervening in this charged space, which is anathema to beauty, poetry or art, creates a perceptive dislocation that emphasizes the impact of the piece. Having said that, politics is often in the back of my mind and frequently informs my choices directly or indirectly.

Usually there's a narrative of some kind running through my work, even in the case of the simplest and most immediate pieces. Some of the pieces are one-liners, "visual puns," and some are slightly more elaborate, but there is always a beginning, a middle and an end. I guess I hope that people will take the time to "read" the piece, though I am content with people deriving whatever interpretation they want as long as they can detect humour and ultimately a certain positivity and optimism.

Some pieces I've done are darker than others, but there is nothing "darker" in my opinion than something that tries to deny the presence of darkness in the world.

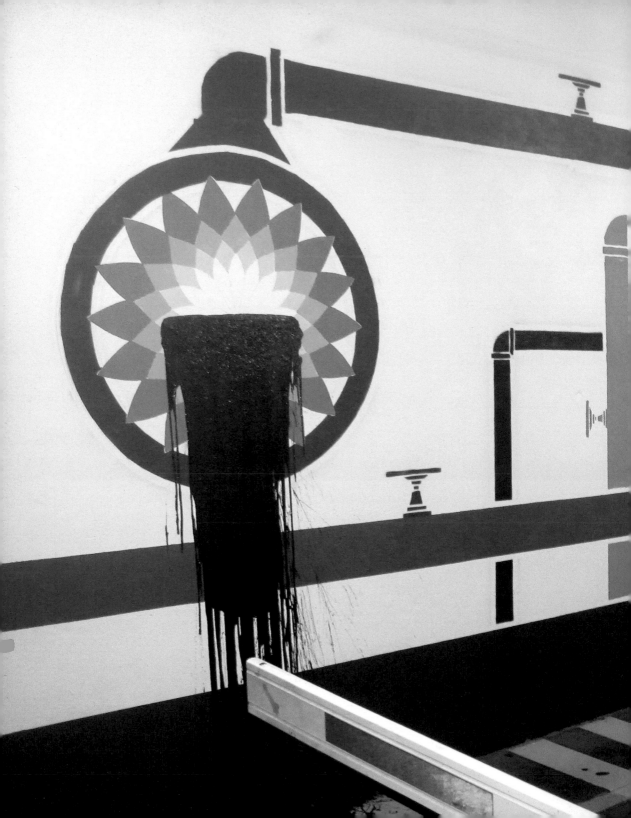

Saída de Peões
Elevadores

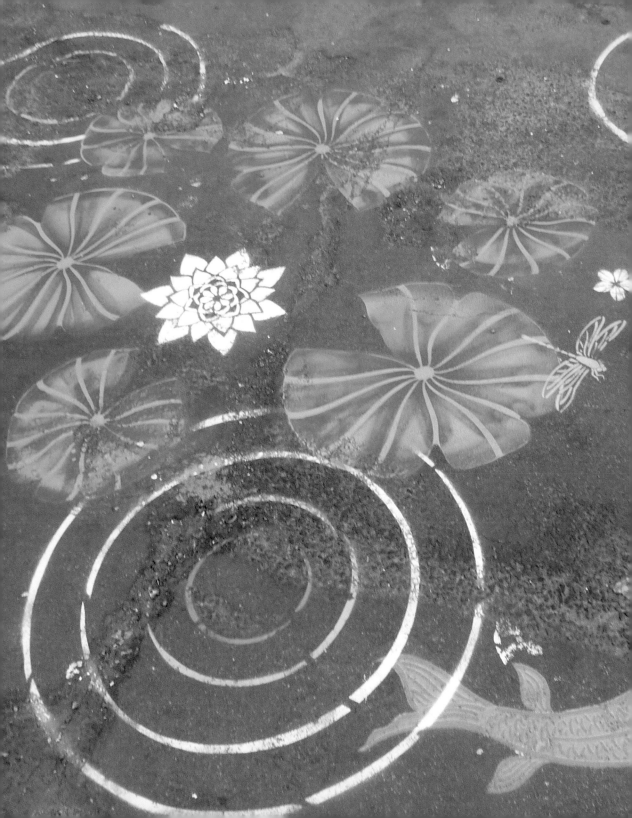

EPHEMERALITY

Around the time that Roadsworth started his stencil work on the streets of the city, he was experimenting also with elements of nature on those occasions when he found himself in a forest or field. "Gluing" icicles together, packing snow, scraping dirt, arranging flowers and leaves, necessarily meant creation of temporary effect. His roadwork — though over a longer period of time — also fades and rubs off.

The big lie behind "ephemeral" art is that it has a fleeting existence, that it exists beyond the world of materiality where stuff can be acquired. There's the pretension that ephemeral art means non-attachment on the part of the artist, as though process is what's important and not the end product. That may be true to a certain extent, but it seems that a lot of "ephemeral" artists aspire to the photo as much as to the process. The documentation is the real end product, and for me that is the objet d'art — especially when it comes to "nature art." Not to say that there isn't a pure enjoyment involved in the process, but capturing the photo is like capturing a butterfly and placing it in a glass case. It's as much concerned with preserving the moment — defying ephemerality — as a canvas does the painter's brush strokes or artistic process.

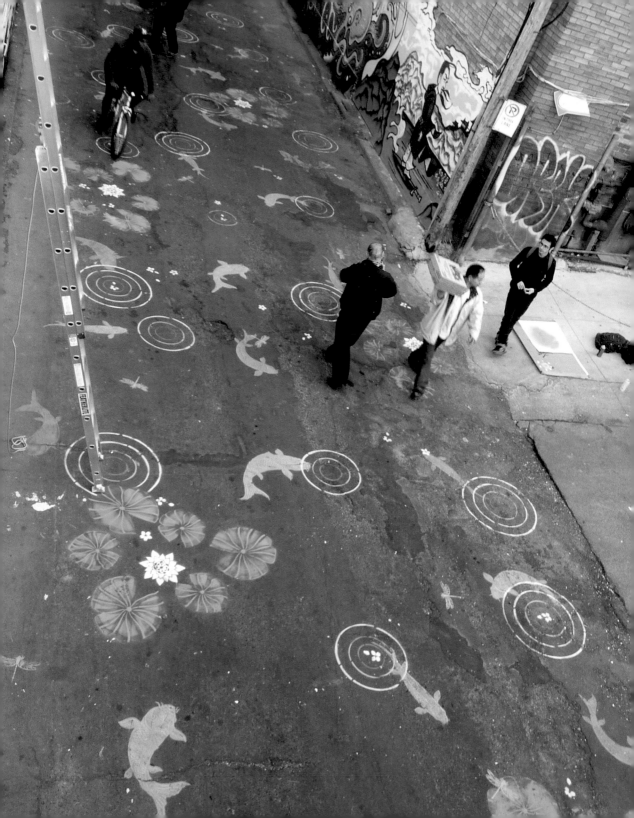

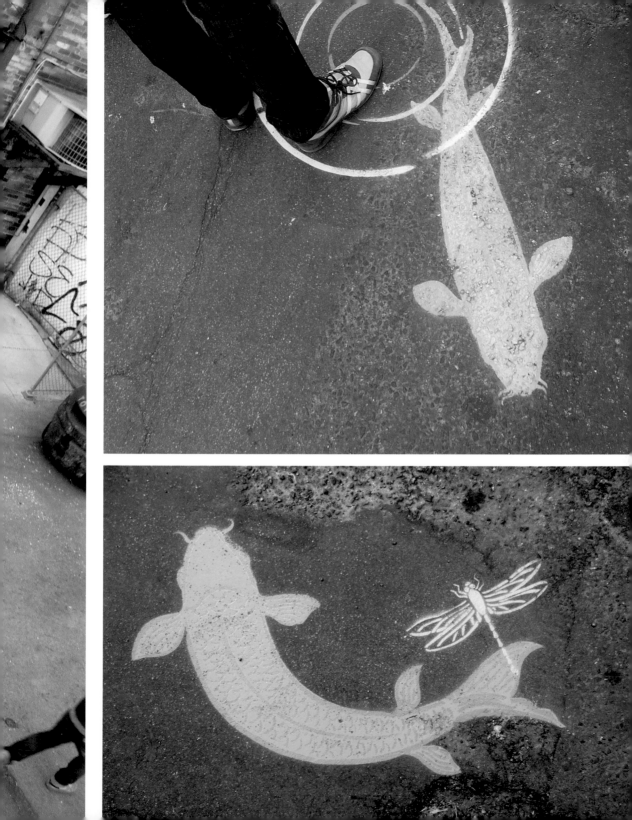

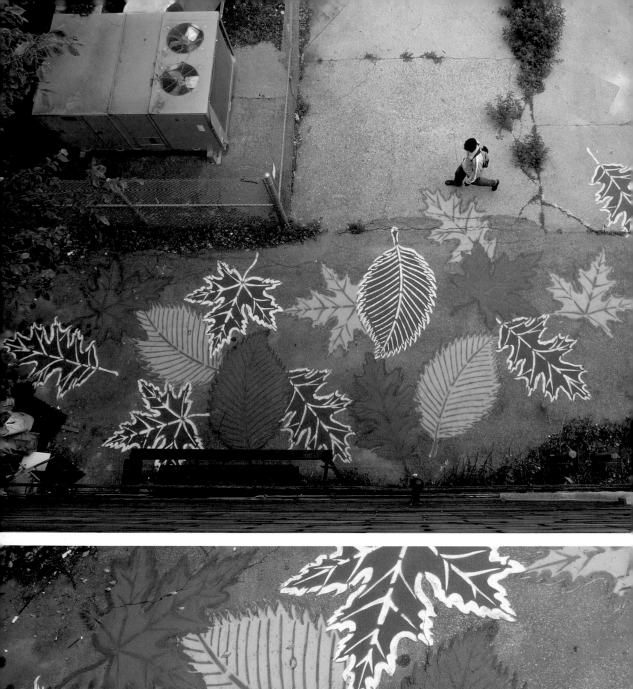
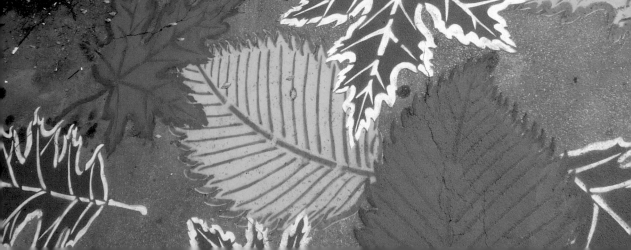

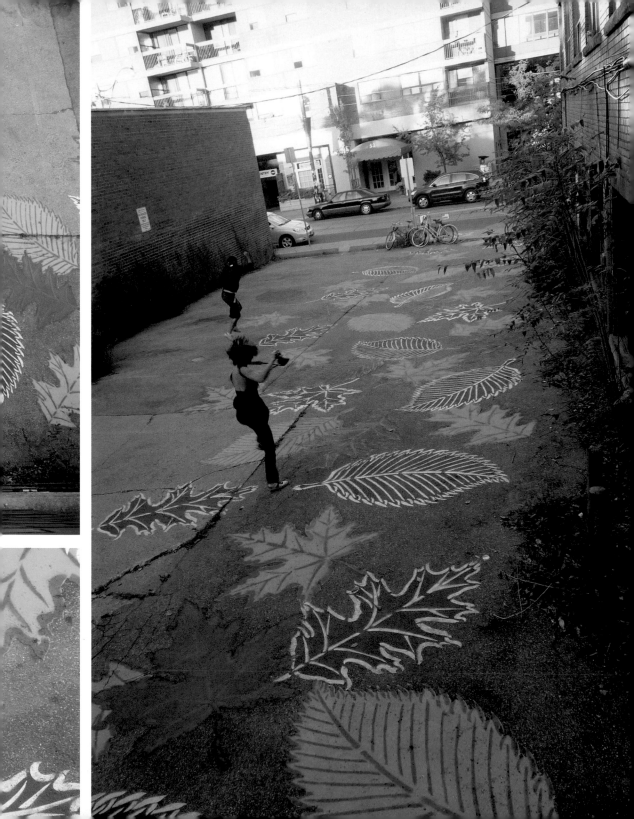

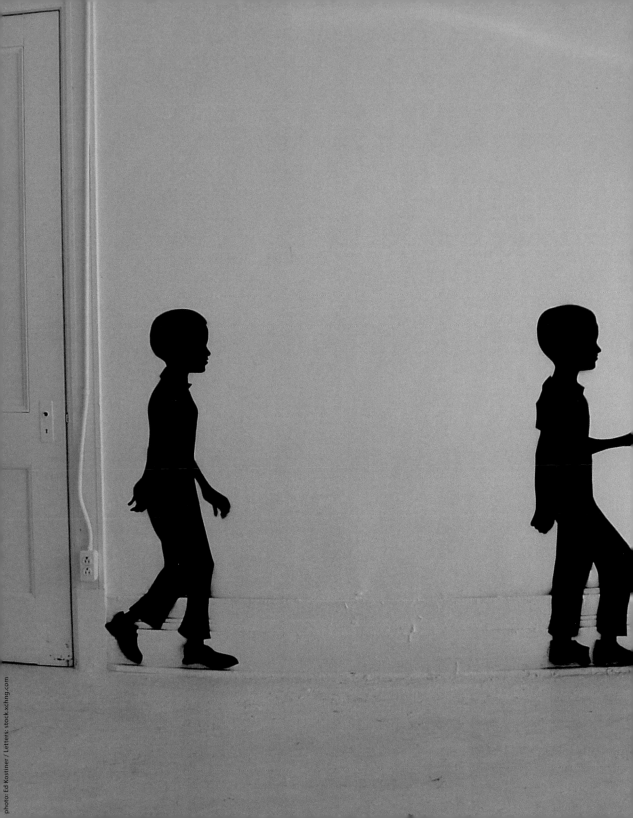

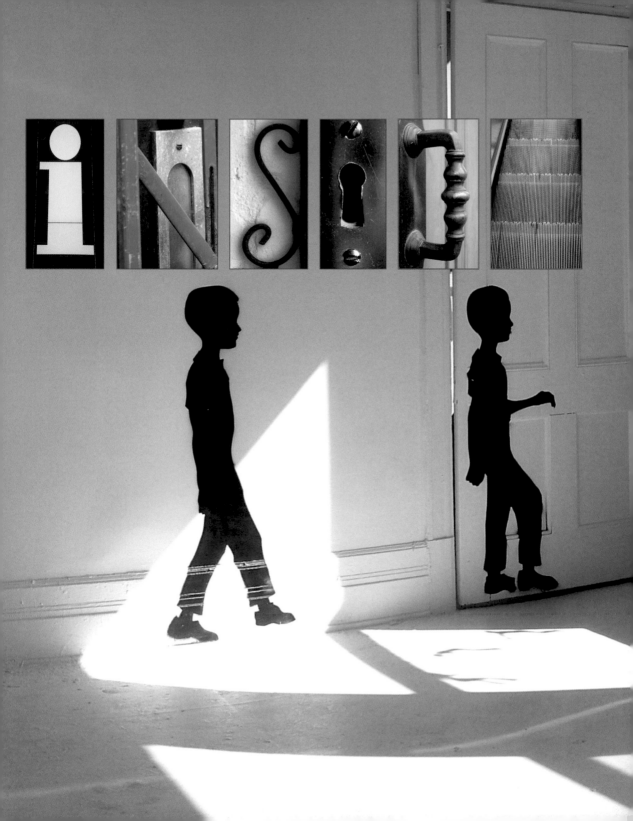

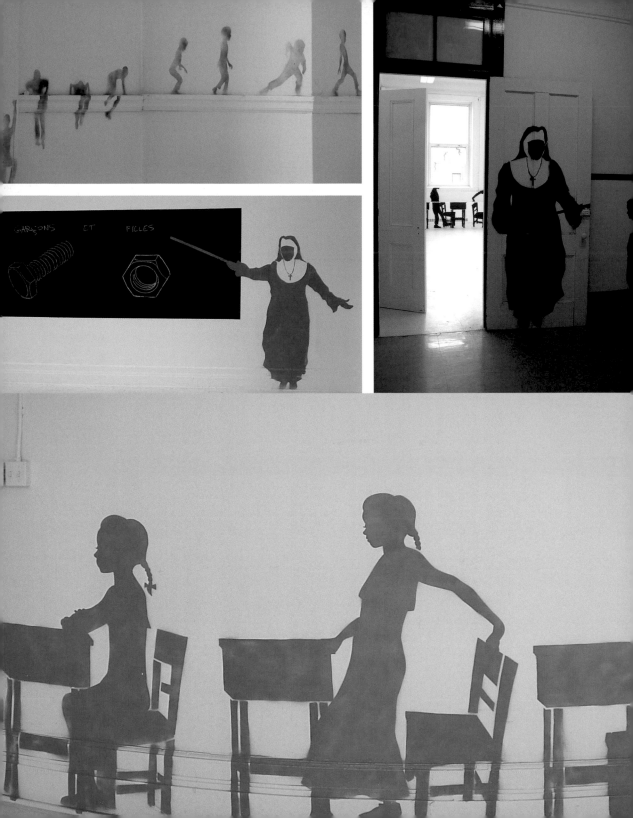

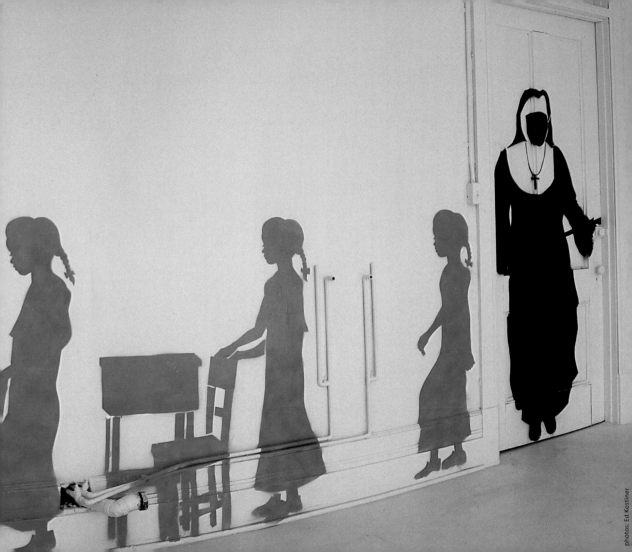

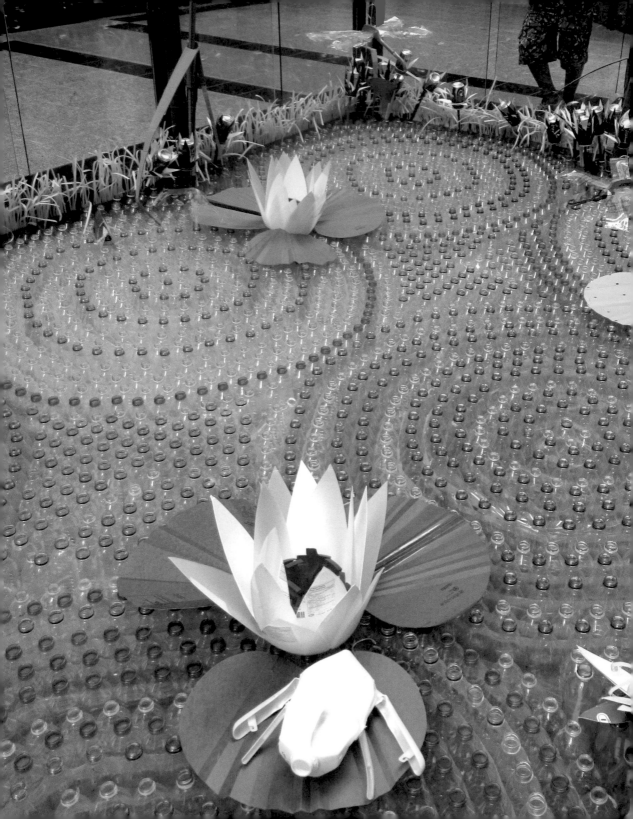

While street art and commissions present challenges that can be exciting, both in terms of execution of ideas and because of their performance nature, Roadsworth is working on bringing a greater degree of calm reflection to his process. He's experimenting with different materials, and has started, when opportunities present themselves, to work indoors.

> One of the things I'd been thinking about is working in a more sculptural manner, working with three-dimensional aspects of the city landscape, introducing three-dimensional elements, recycled materials.
>
> The Montreal Eaton Centre approached me to do something inside. It was hard to refuse; I wanted to try something sculptural, in an indoor space, on a vertical plane — all new experiences. It was suggested to me that I come up with drawings that could be transferred to vinyl, which could then be stuck onto surfaces inside. The thought of creating waste in the form of vinyl I found vaguely depressing. And the space is so sterile and clean I wanted to do

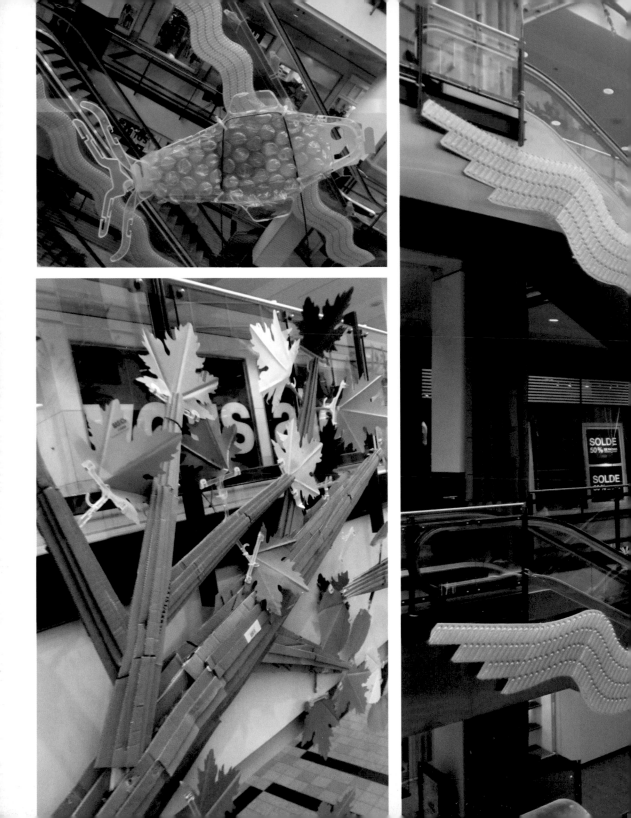

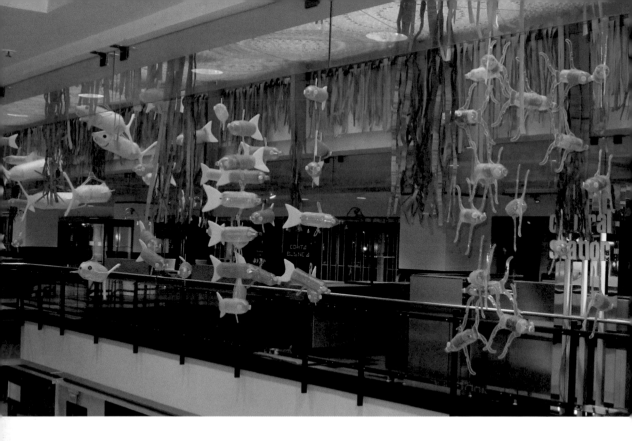

something to contrast that. Using the waste material of the mall is a powerful way to comment on the function of the mall in general, and consumerism, without being preachy.

In some ways, working in a mall is closer in spirit to street art than working in a gallery. A mall is one of the last places you'd expect to see art. You see something in an art gallery and you know you're looking at art; anywhere else, people have to decide for themselves.

The perception is sometimes that I'm compromising in some way when I work inside, that I'm being prevented from painting the road or from working outdoors. But different contexts just push you to come up with more solutions, techniques, skills.

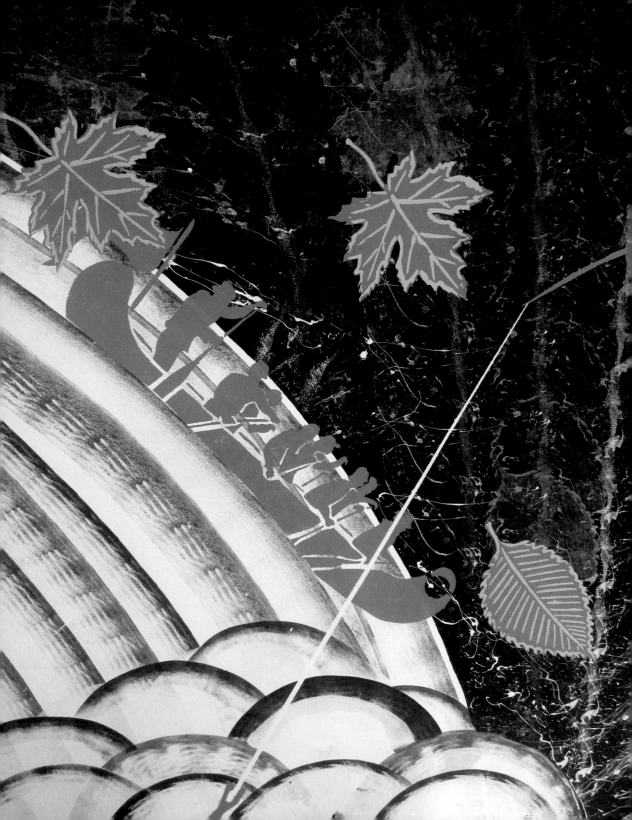

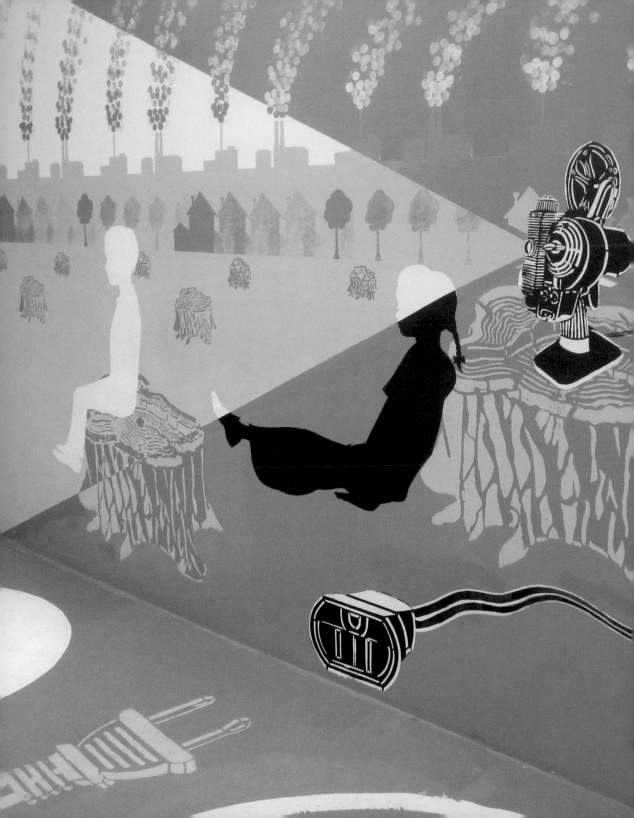

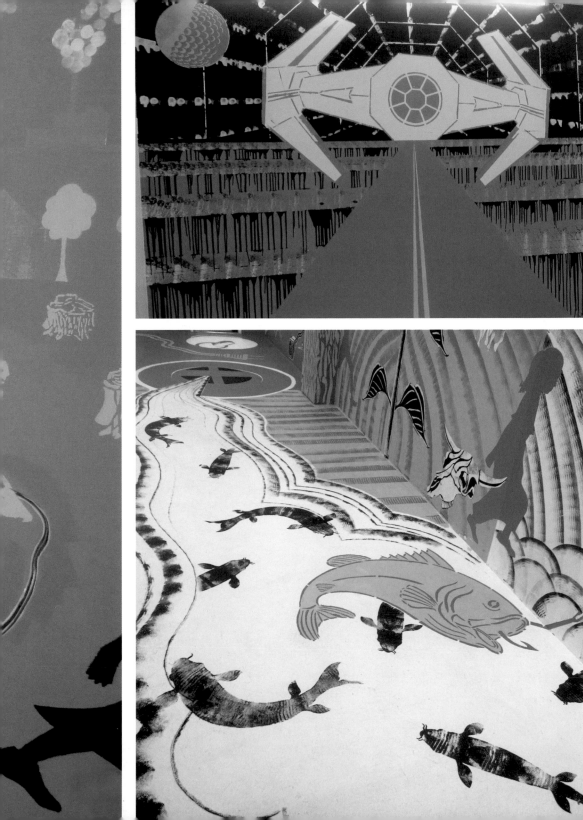

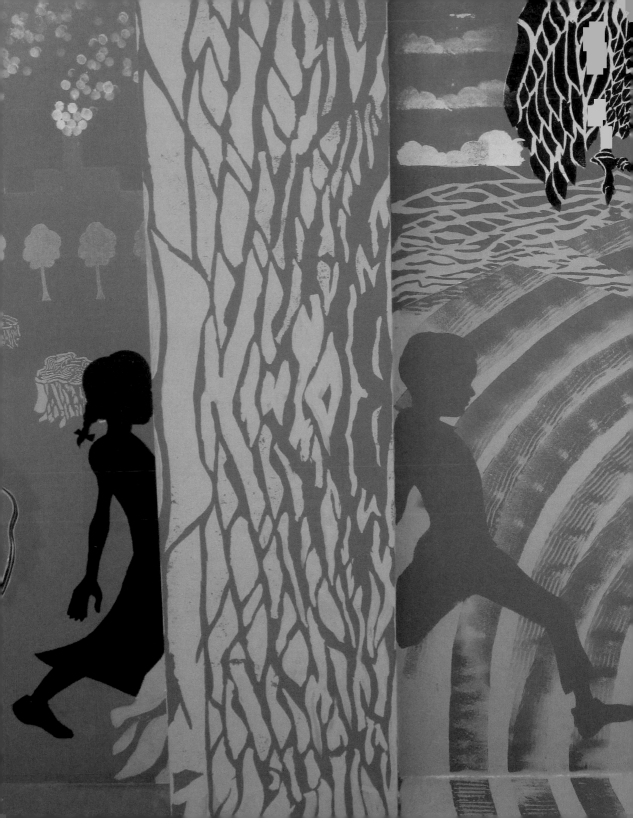

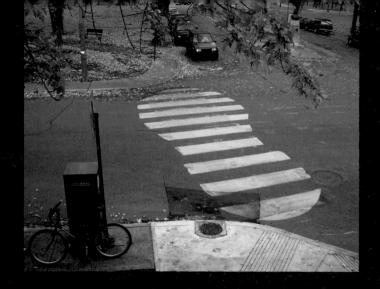

BEYOND

I've got concerns bubbling under the surface. Beyond using other materials, I am thinking of incorporating text in some way, also taking shadow work to the next level. I want to try working more abstractly, using less literal forms. I'm also thinking about "natural" movement — maybe trying to create a more concrete kind of animation.

Street art is in its infancy, the possibilities are endless. There's so much potential for craziness.

CHRONOLOGY

Commissioned installations, unless otherwise noted.

1973 Roadsworth born,
December 12, 1973, Toronto

1999 BMus, Jazz performance (piano)
McGill University, Montreal

2001 First street intervention,
October 2001, Montreal

2004 Arrest

2005 March 25 – April 27. Paperjam, Madame Edgar, Montreal. Group show.

August. La TOHU [tohu.ca] La Cité des arts du cirque,
2345 Jarry St. East, Montreal

October 4 – 9. Homage to Victor Jara, Station C, Montreal

July – September. Débraye: voiture à controverse. The Darling Foundry
[fonderiedarling.org], 745 Ottawa St., Montreal

September 1 – 10. Off-Courts, The Trouville Short Film Festival
[off-courts.com]. Trouville, Normandy, France

October 21. NEXT Launch at Festival du Nouveau
Cinéma [nouveaucinema.ca], Musée juste pour rire, Montreal

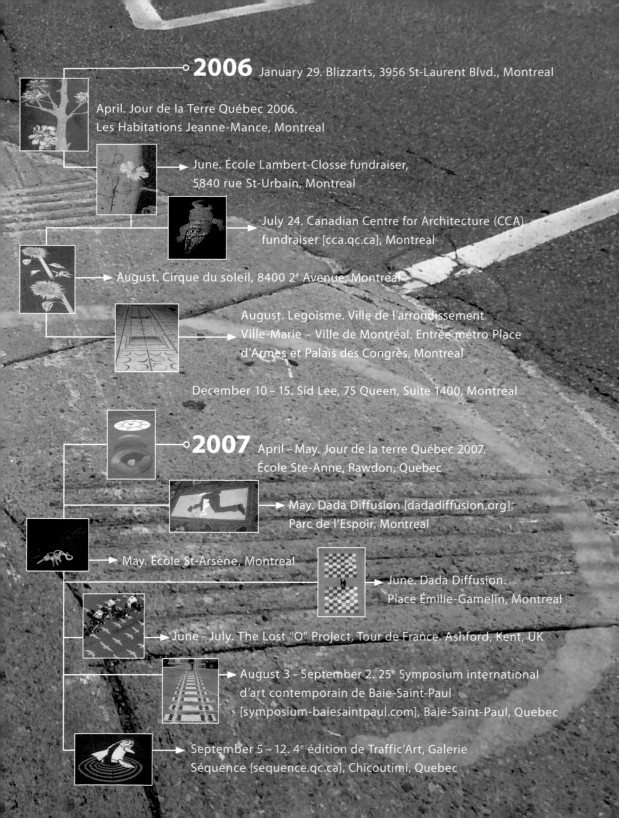

2006 January 29. Blizzarts, 3956 St-Laurent Blvd., Montreal

April. Jour de la Terre Québec 2006.
Les Habitations Jeanne-Mance, Montreal

June. École Lambert-Closse fundraiser,
5840 rue St-Urbain, Montreal

July 24. Canadian Centre for Architecture (CCA)
fundraiser [cca.qc.ca], Montreal

August. Cirque du soleil, 8400 2ᵉ Avenue, Montreal

August. Legoisme. Ville de l'arrondissement
Ville-Marie – Ville de Montréal. Entrée métro Place
d'Armes et Palais des Congrès, Montreal

December 10 – 15. Sid Lee, 75 Queen, Suite 1400, Montreal

2007 April – May. Jour de la terre Québec 2007.
École Ste-Anne, Rawdon, Quebec

May. Dada Diffusion [dadadiffusion.org].
Parc de l'Espoir, Montreal

May. École St-Arsène, Montreal

June. Dada Diffusion.
Place Émilie-Gamelin, Montreal

June – July. The Lost "O" Project, Tour de France. Ashford, Kent, UK

August 3 – September 2. 25ᵉ Symposium international
d'art contemporain de Baie-Saint-Paul
[symposium-baiesaintpaul.com], Baie-Saint-Paul, Quebec

September 5 – 12. 4ᵉ édition de Traffic'Art, Galerie
Séquence [sequence.qc.ca], Chicoutimi, Quebec

2008

May 3 – 5. 2008 Cans Festival
Curated by Banksy. London, UK

May. Mois de l'art imprimé.
Galerie ARTPRIM [arprim.org],
Montreal

July. Révitalisation Ville St-Pierre.
Centre de révitalisation urbaine
de Ville St-Pierre, Montreal

Roadsworth: Crossing the Line
Loaded Pictures and the
National Film Board of Canada.
Feature film.

2009

February. Lance Armstrong
Foundation — Amgen Tour
of California

May. Montreal Biennale of
Contemporary Art 2009
[biennalemontreal.org],
Montreal

June – August. Aires Libres.
SDC du Village. Montreal

September. Manifesto Festival
of Urban Music and Art, Toronto

October. Inside Out: Artists in
the Community II. South Eastern
Center for Contemporary Art (SECCA),
Winston-Salem, North Carolina, US

2010

January – February. Here in My Car. Artcite Gallery, Windsor, Ont. Prints/Documentation.

April. Mayor's 20-minute Makeover. Well and Good Gallery, Toronto

September. En Ville Sans Ma Voiture 2010. En collaboration avec le Conseil régional de l'environnement de Montréal, Montreal

October – November. OFF & ON. Atelier PUNKT, Montreal. Solo exhibition.

December. Pop Up: Urban Arts Festival. Lisboa, Portugal.

2011

May. One Drop Foundation. Montreal

May. Artung. Montreal. Workshop, live painting.

May – June. Manayunk Philadelphia Mural Arts, Philadelphia

June. G66+Live Community Cultural Festival. Kirkintilloch, Scotland

July. Centre Eaton, Montreal

July. MU Mural. Verdun, Quebec. Mural painting, in collaboration with Phil Allard.

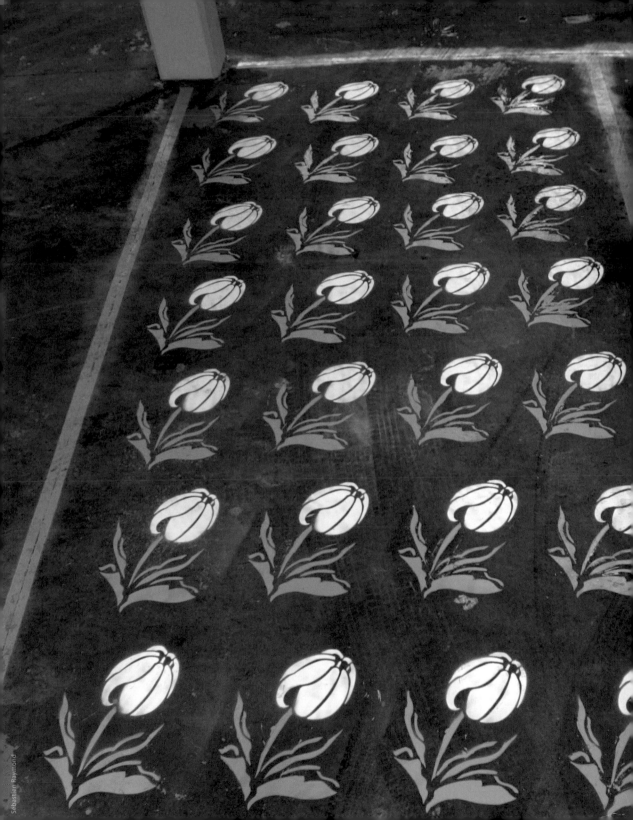

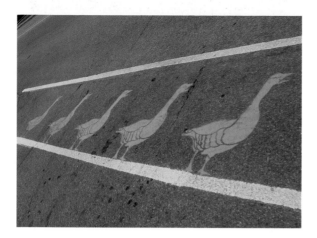

Thanks to everybody at Goose Lane, especially Julie Scriver and Susanne Alexander. Thanks also to John Sweet. Special thanks to Chris Hand, Jean-Philippe Desmarais, Marc and Sara Schiller, Loaded Pictures and all of the peeps in Montreal who supported me in a time of need. Shout outs to Phil Allard, Brian Armstrong and Karim Sikander for their hard work, talent and humour, and to Pablo Aravena, Francisco Garcia, Sebastien Astoux, Alan Kohl and Pat McGee for their early and continuing inspiration. Thanks, too, to Scott Burnham for his generous contribution to this project. Very special thanks to Mum and Dad for piano lessons and for their good example, Sarah Seabrook for teaching me to tell the time, and especially Bethany Gibson without whom this book wouldn't exist. Love and gratitude to my number one ally Nikoo Asadi.

— Roadsworth

Thanks to John Sweet for the good work. Big thanks to P for the excellent job. Such love and gratitude to Glenn (my secret weapon), Miriam, Felix and Ivy.

— Bethany Gibson

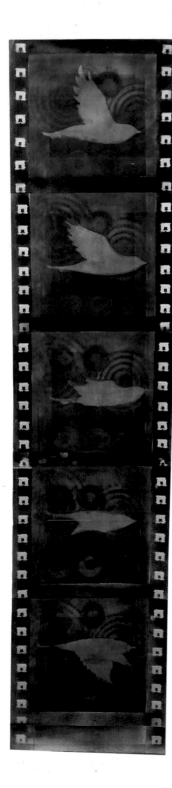

Edited by John Sweet.
Cover and page design by Julie Scriver with big inspiration from Roadsworth.
With the exception of documentation images on pages 90-93 and 101 (zipper), all photographs by Roadsworth unless otherwise noted.
Printed in Canada.
10 9 8 7 6 5 4 3 2 1

Library and Archives Canada Cataloguing in Publication

Roadsworth
 Roadsworth / Text by Roadsworth and Bethany Gibson with a foreword by Scott Burnham.
ISBN 978-0-86492-638-8

1. Roadsworth. 2. Graffiti artists — Québec (Province) — Montréal.
3. Street art — Québec (Province) — Montréal. I. Gibson, Bethany. II. Title.
ND2643.M66G53 2011 751.7'30971428 C2011-902885-9

Goose Lane Editions acknowledges the financial support of the Canada Council for the Arts, the Government of Canada through the Canada Book Fund (CBF), and the New Brunswick Department of Wellness, Culture, and Sport for its publishing activities.

Goose Lane Editions
Suite 330, 500 Beaverbrook Court
Fredericton, New Brunswick
CANADA E3B 5X4
www.gooselane.com

FSC
www.fsc.org
MIX
Paper from
responsible sources
FSC® C016245